Merry Christmas

I know you'll enjoy the
beauty in flowers just as Diana
Did. Enjoy reading this wonderful
Book. Flowers Have always been Special
to the both of us. A beauty that God
can only give us — what a Gift!

love you mom

Tamera

KIP'S FLOWERS

for

DIANA

KIP DODDS

Photography by

ANDY EARL

SIDGWICK & JACKSON

To Steve and Abi

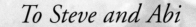

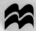

First published 1999 by Sidgwick & Jackson
an imprint of Macmillan Publishers Ltd
25 Eccleston Place, London SW1W 9NF
Basingstoke and Oxford
Associated companies throughout the world
www.macmillan.co.uk

ISBN 0 283 06348 3

3 5 7 9 8 6 4 2

A CIP catalogue record for this book is available from
the British Library.

Designed by Neil Lang, Macmillan General Books
Photographic reproduction by Speedscan Ltd., Basildon, Essex
Printed and bound in Italy by New Interlitho, Spa, Milan

CONTENTS

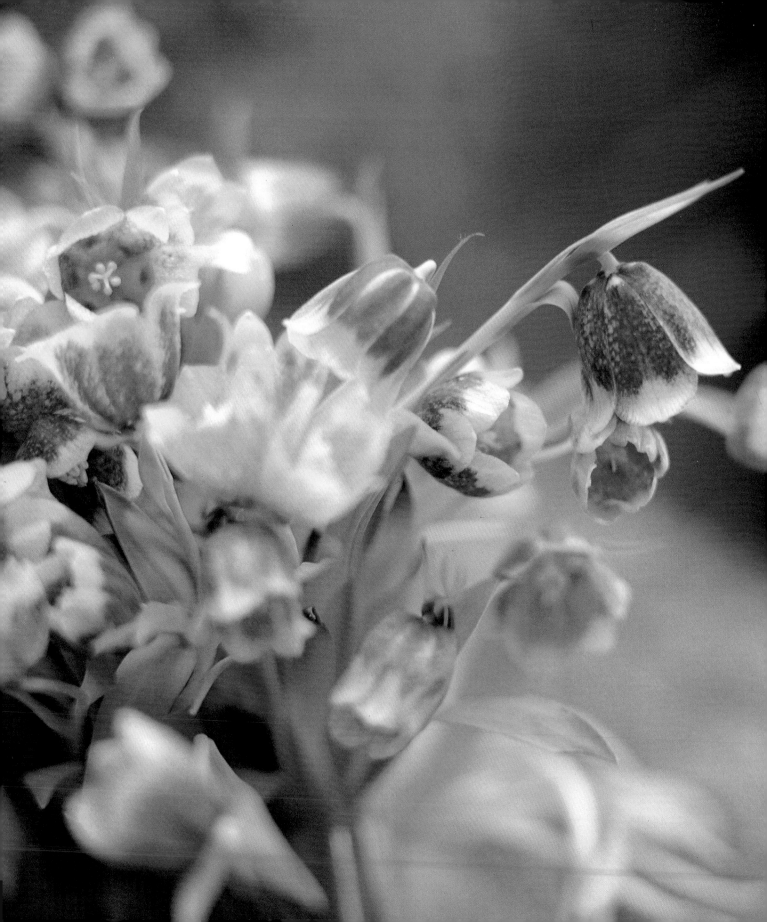

FOREWORD

When Diana, Princess of Wales, first heard Kip's distinctive but familiar accent, she enquired as to which part of the country he originally came from. The answer was Derbyshire. 'Well, he's obviously made of good stuff then,' she responded.

One evening, I took her past Kip's shop in the car, as she wanted to glimpse where all the marvels she saw every day were put together. Peering through the window, she was amazed at 'how untidy yet how organized' everything seemed.

Kip always made it easy for her to find presents for her guests, friends and family, such as scented candles and beautiful hand-tied bouquets of seasonal flowers.

Princess Diana was always delighted with Kip's flowers. She loved his unusual approach to his work and the simplicity and naturalness of his arrangements.

Paul Burrell

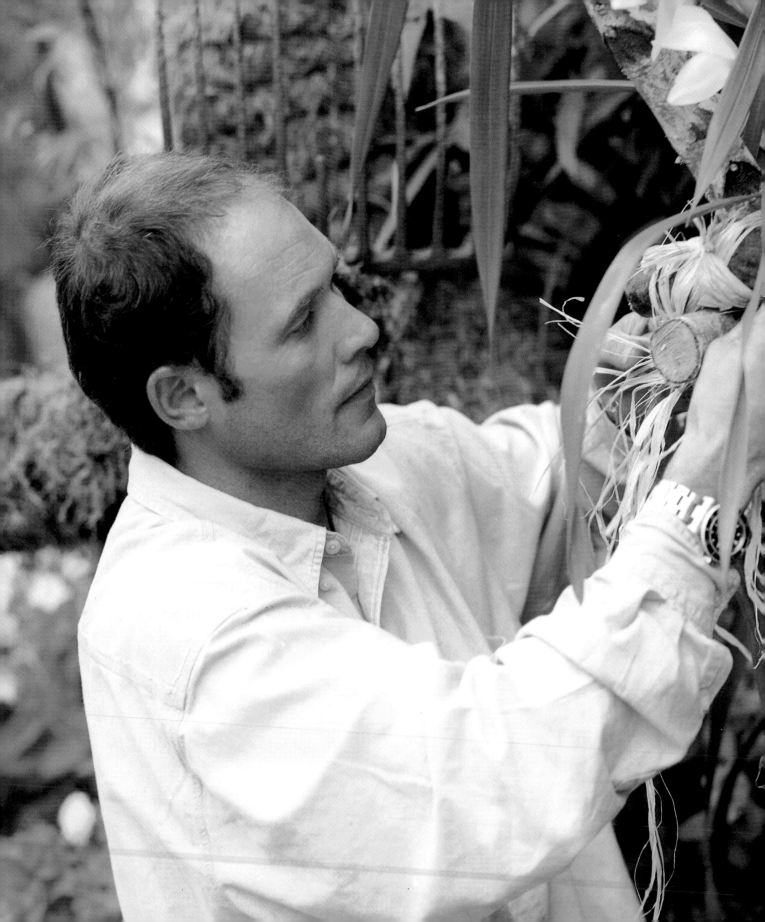

KIP'S STORY

I can't think what triggered my obsession with gardens. I was never particularly academic at school – I was chucked out of gardening lessons because I couldn't do the written work, and I was too shy to put my hand up in class even though I did know a lot of the answers. From quite early on I loved looking at flowers. I guess it started on the walks to school. Every day I used to pass a fantastic garden that had a beautiful lawn and flowers and vegetables, all growing together in the borders.

I grew up in Derbyshire, on a council estate in Matlock. There were three of us: my brother, my sister and me. My mum brought us up alone, and we had all been born by the time she was sixteen. Matlock is on the border of the Peak District National Park, one of the most dramatically beautiful and rugged parts of England. Hurst Farm Estate, where we lived, skirts the edge of Matlock and gives way to a breathtaking panorama of hills, valleys and forests peppered with crumbling manor houses and churches built from the local millstone grit.

Beetroot and brussels sprouts. I used to grow all sorts of vegetables as well as flowers in my garden – and I often use them together in arrangements now, too.

Our actual backyard, however, was concreted over – we kept our bicycles out there, and we had a swing and a climbing frame, too. I'm not sure what gave us the idea, but one day when I was about twelve my brother and I borrowed a couple of hammers and chisels from our next-door neighbours. For three weeks every day after school we chipped away at the concrete. Bit by bit we uncovered all kinds of junk – bits of cars, prams, bicycles and bedsprings – before we finally struck soil. It was fantastic when we saw proper earth for the first time: we felt triumphant.

Eventually we decided to put down some grass seed. We didn't have a clear idea of what we were hoping to achieve – just that it should be green. Of course, we didn't have a lawnmower or shears, so we had to cut the grass with scissors. I loved doing it, even though it took two days! Other kids thought it must be a punishment. But since by any standards I come from a fairly eccentric family they probably thought we were indulging in some strange, off-the-wall ritual.

After a while I got bored of the lawn and decided the garden needed a little character. I resolved to terrace it, then added a rockery and also created a 'secret' garden. We started the actual planting with easy things like potatoes and radishes and then, helped by our neighbours who gave us seeds and cuttings, we got more adventurous. At weekends I went to the local garden centre to look at flowers and plants. If someone moved out of a house nearby I would nip in and dig up shrubs and roses to plant in our own garden! I was lucky, most things grew – some spectacularly well.

I think one of the most striking memories I have of this time is building a proper greenhouse with the help of a neighbour. It allowed me to expand my repertoire, and soon it was

producing tomatoes, cucumbers, melons, grapes and bedding plants. I had a very strong picture in my mind of what the greenhouse should look like even before we began building it. In retrospect, I think this was a skill I was developing to overcome some of the problems of being dyslexic. It's what I use when I'm working out really large-scale things now – grand, ambitious decorations for weddings and special occasions. A very clear visual image will come to me, and then I'll make up the arrangements accordingly.

Once I got that garden going I felt more enthusiastic about doing the schoolwork. But by then it was too late – I tried joining the gardening club but they wouldn't let me because I couldn't spell geranium (and I still can't!).

After I left school, aged sixteen, I had no qualifications apart from an art O level. I answered an ad to work as a greenkeeper at the Matlock golf course. I got the job! I worked there for six years, mowing grass and fertilizing the greens and fairways. The members were rather snotty and I was never invited into the clubhouse, but I learnt a lot about grass! As a result, I turned that back garden at home into a proper lawn – it was immaculate. I used to get up at six in the morning and rake it and brush it, and then I'd come back every evening to mow it and spike it. When my sister returned home after being away for a while and saw the lawn for the first time she thought it was a carpet – she just couldn't believe it was real grass! I must admit, it did look a bit out of place in the middle of the estate.

At about this time, through my mum's

Sir Norman Foster's park at Compton Bassett in Wiltshire.

boyfriend, I met Brian Clarke, an artist. He came from the next village. It was a friendship that changed my life. Brian had just moved to London and was doing really well, and many of his friends were pretty famous – or, like him, destined to become so. He used to ask me down to parties and through him I met Mick Jagger

The shop, a week before it opened. I did all the fixing up myself, as well as decorating and building the counters.

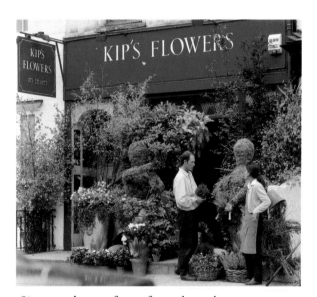

Six years later, after a few colour changes. Outside, I always have a seasonal display planted out – often using moss sculptures, old tools and things I hope will catch people's eye.

and Jerry Hall, Marie Helvin and David Bailey, Robert Fraser, Jools Holland, Donald and Linda Pleasance, John Swanell, and Linda and Paul McCartney, many of whom were to become clients. When people found out what I did they began to ask me to do little bits of work for them when I came to London. So I'd spend the week in Matlock working for £1.20 an hour at the golf club, and then I'd come down and do window boxes and pot plants in London for £5 an hour. One day I thought, 'Hang on a second, why not do the gardening full time?'

So, in 1986, I moved to London. I'd spend half the time gardening, and the other half creating and tending the architect Sir Norman Foster's 70-acre park at Compton Bassett in Wiltshire. When I arrived, 20 acres of it was woodland, the rest just grass. I loved it because Norman left me to my own devices and I transformed the land around the house from a jungle into something more akin to Norman's sense of order and elegance. It was the most wonderful opportunity you could imagine. I grew to love Compton Bassett Park as if it were my own, and Norman and his son Ti encouraged me to use my own instincts to make a real contribution to the landscape.

After a while I got restless and wanted more of a challenge. Eventually, in 1992, I took out a lease on a tiny shop in Campden Hill Road, between Kensington and Notting Hill, to act as a base for a gardening and floristry business. In order to make the second part of this scheme work, I rang a friend of mine, Robert Young,

who runs a florist and garden centre in Matlock, to see if I could go and work for him for a few days and find out if I could really get the hang of things. His style is very different from mine – more traditional – and I was dreading the moment when he might ask me to do an arrangement. But it was very useful. The first lesson he taught me was not to be scared to throw flowers away if you hadn't used them in three days – otherwise the customer wouldn't enjoy the best of them. I learnt how to condition flowers, too – treating the stems to make them last – as well as how to wire blooms and make bows. We've become very close friends since, and we now work together a lot.

Everyone said I was mad opening a business – firstly because it was the height of a recession, and secondly I really didn't know much about flowers – I didn't even know how to wrap up a bunch of tulips! Even the shop's most recent incarnation – as a tanning and beauty parlour – had been a failure. However, I was determined to have a go. I saved up £500 and went to New Covent Garden, the big wholesale flower market in Vauxhall, across the river from the Houses of Parliament, at about 3 a.m. and bought armfuls of tulips, daffodils, lilies, stocks, jasmine and azalea plants. I had no idea of what might sell or how I was going to put them together, so I just bought what I liked. To my amazement, when the shop opened people were buying them as fast as I could unpack them – we sold out in about two hours.

After a few months the business was going really well. The shop seemed to fill a gap in the

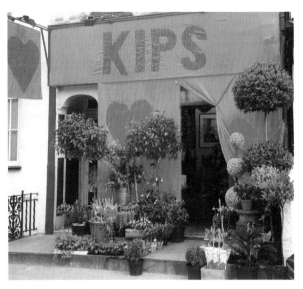

The Valentine's display which caused all the fuss. Campden Hill Residents' Association thought it was a bit too eyecatching, and tried to persuade me to take it down.

The year after, we decided to play safe, and decorated the inside of the shop quite a bit more vibrantly instead.

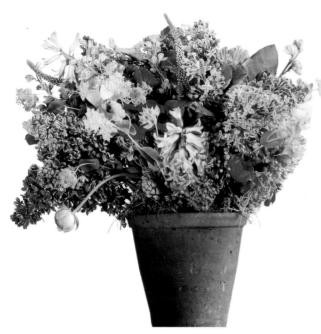

*That lopsided first arrangement. Far right,
the Sunken Garden at Kensington Palace.*

life of that quiet residential area and now we were becoming something of an attraction. Part of this was because the display area inside is so small that all the flowers and plants have to spill out on to the pavement. I also like to make something of the outside, perhaps decorating the whole shop front in orange for Valentine's Day (some of the neighbours complained!), or with enormous topiary sculptures on each side of the door. What I also like is that while we're in the heart of a city, there's still quite a villagey feel to things.

A bloke called by one day and said he was Paul Burrell, Princess Diana's butler. His accent was very familiar – he comes from the same part of Derbyshire as me – and I thought to myself,

'Yeah, yeah.' So I stayed out of the way, watering the plants on the pavement, and my assistant Abi served him. He asked her if we would be interested in doing the flowers at Kensington Palace. Of course, we said yes, but thought no more about it. It all seemed so unlikely.

The next afternoon I got the call. Could we provide some samples of our work and drop them off at St James's Palace, where Diana's office was? We panicked. We had virtually nothing left in stock, so I ran to a neighbour's garden and picked lilac and roses. I even fell off a wall in the process! Nervously I made an informal arrangement. I went for the rather haphazard effect which I love, the contents tumbling over the side, and very fragrant. I thought this would stand out from the Princess's formal surroundings. I was really pleased with it, but of course had no idea if she would like it. We sent it round with another, smaller arrangement in yellow, made up of daffodils, ranunculus, tulips and mimosa. I wanted to send what I liked, not what she might have expected.

Two hours later Paul phoned to say that the Princess wished to pay for both of the arrangements, because she wanted to send them as gifts to a friend. What's more, she wanted to know whether Mr Kip (as she would always call me) would do all her flowers from now on? Of course, we were over the moon – we went out and bought loads of champagne. I couldn't quite believe it, and was too nervous at the thought of what was going to come next to tell anyone else! In fact, I kept it to myself for ages.

As a result of that first arrangement, we used to send flowers, or go to Kensington Palace ourselves, almost every day for the next four years. Paul arranged lots for her, too. Sometimes we sent the flowers up for him, but if he had time, he'd go to the market himself.

The first time I was there I remember standing in the dining room, thinking how amazing it was to be there, and how I wished all those old golfers and teachers could see me.

When I actually saw the Princess, she was in the distance, and I just couldn't believe how long her legs were. She was stunning, and very sexy. Paul introduced us. She was incredibly friendly, and instantly put me at my ease. She seemed to know all about me. I felt as though I'd known her for a long time already. I think this quality of hers must be one of the reasons why she was so amazingly popular.

When I think about why the Princess liked what I did I think it must have been that relaxed, slightly casual approach I'd shown in the first arrangement. After all, neither of us had any formal background in plants and flowers, and even less in what was 'meant' to go with what. But we were both instinctive, wanting to try out new ideas, and I think we connected on that level. I know that for as long as I worked for her, other florists kept sending her their portfolios, but she was never persuaded by what they offered.

I'd just come back from holiday when I heard the news that she'd been killed. It was six in the morning. I just couldn't believe it – I still can't. I sat in front of the telly and cried all day. I was invited to the funeral along with my friend Steven, who'd helped me out at the Palace a lot, but I can't remember much about it. My girlfriend Isabel videoed it for me, but I haven't been able to watch it yet.

Because of my work I've been lucky enough to meet many famous people, but she was unique. Different people who've worked for me all agree: there was something magical about her. It was always a pleasure and a thrill to be let past the crowd of tourists and through the Palace gates. Even if you didn't see her, you knew she was around – there was something in the air.

I can't really explain how I feel about her now, except to say that I still find myself at the flower market at three o'clock in the morning, choosing all the flowers that I know she would have liked best. I am very proud to think that I was the florist to the Princess of Wales.

WHAT ARE KIP'S FLOWERS?

I have loved flowers for as long as I can remember being able to love anything. I think it's because they hold in their leaves and petals, their colours and smells, the essence of the countryside, the spirit of nature.

There are a lot of rules and regulations in floristry. I don't follow those rules – or to be honest, even know what they all are! Sophisticated, grand floral displays are not my thing. I hate to see flowers forced into fancy concoctions, the poor things looking as though they've been murdered – suffocated at the whim of a decorator.

For me, flowers are a breathing part of nature, an expression of everything that is fresh, good and fine. Like food or water, they feed us and bring into our lives something much more precious than fame or status ever can. Flowers, like children, bring into a home something pure, innocent and happy. The Princess understood that too, and that shared understanding changed my life.

What I want to do is to convey the sense I had of Diana, Princess of Wales, in the best way I know how: through the flowers, the colours and the scents which seemed such an important part of her daily life. It's an intimate response to an extraordinarily charismatic and complex woman, who by chance became my friend.

The public perception of Diana was of a very urban woman who loved her city life. However, during the time that I worked for her, I came to understand how much she also adored the countryside – although not necessarily country living! – and the relative freedom and privacy it offered her. She used to drive off to Wiltshire to see her boys at school, unannounced, and without telling anyone where she was going. It drove the security men mad! When she wanted to be alone, she loved to go on coastal walks near the Queen's estate at Sandringham in Norfolk. She also liked woodlands. By way of escape in town, she would head off into Hyde Park for a run or to rollerblade, disguised in a hat and dark glasses, and occasionally would sneak out to sit on the grass in the sun to read a book or sunbathe. For Diana, flowers were also a way of changing her environment.

But this book is also an attempt to put into words and pictures how I earn a living. When I wrap an arrangement in brown paper, there's a sticker I use to hold the loose ends together. On it is written the effects I am trying to achieve: Refreshing, Vibrant, Colourful, Creative, Inspiring. Each section of this book attempts to pick out a different strand of this philosophy.

For instance, I've tried to illustrate what an impact the use of colour and scent has, the power of simplicity, and why not to be afraid of ingenuity. And because I couldn't resist, I look at all the flowers that are my favourites – and were the Princess's, too.

It's not a how-to book, although I'm certain that all the arrangements featured in the book could be done at home. There's lots of information at the back of the book about the kinds of flowers I like to use, when they're available, and some of the arrangements.

As I've said, I've never understood what the 'rules' are. At the end of the day, all I know is that nothing is set. I've always, against the odds, trusted my heart and my instincts. If everything goes horribly wrong, you learn from your mistakes and try again.

I have yet to meet someone who doesn't love flowers. The pleasure they give me in buying and selling them – or, best of all, being given them – can never diminish.

Any visitor to Kensington Gardens will know how lovely its setting is. Besides the rolling park itself, the Palace has its own formal gardens with gorgeous herbaceous borders you can stroll past, as well as the elegant Orangery. But if you were to make it over the spikes on top of the Virginia creeper-clad wall at the side of the Palace, you'd discover a whole other world inside. As well as the main buildings, grouped around its own village green, there are cottages and stables, and borders full of rambling roses.

We started taking the photographs for this book at Kensington Palace on what would have been the Princess's thirty-seventh birthday, 1 July. The day felt very quiet and still. I think this arrangement on the right, shot that day, sums up all the themes of this book. Although the overall impression is the dusky pink of the flowers – and if you could smell it, its heady scent – my starting point was actually the ornamental miniature cabbage. Chunky as they are, I picked up on their delicate colours in choosing the peonies, sweet peas (an unusual variety called 'Barcelona'), 'Sterling Silver' roses and the red of the tobacco plant. When I was carrying the arrangement to the spot where we took the picture, the scent was so powerful I felt quite heady, even though I was out in the open air!

In the beginning, I didn't have any sense of what the Princess liked so I had to work by instinct. The shop had just opened so I didn't have that many regular clients. The most that people usually wanted to spend was £15 to £20.

I've always thought smell was important, and I like flowers to look as natural and unstructured as possible. The messages back from Diana were always positive. That's not to say that the job was always easy: I'd often get a call at eleven-ish asking for a delivery at 12.30 – there were lots of last-minute lunches. When the press were being too overbearing she would decide to invite friends to Kensington Palace rather than go out, so often I just had to work with what I could get quickly. I couldn't agonize about it, and I'm certain that the time factor made me work not

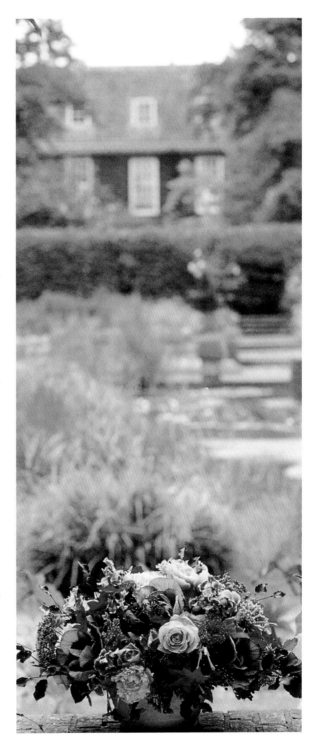

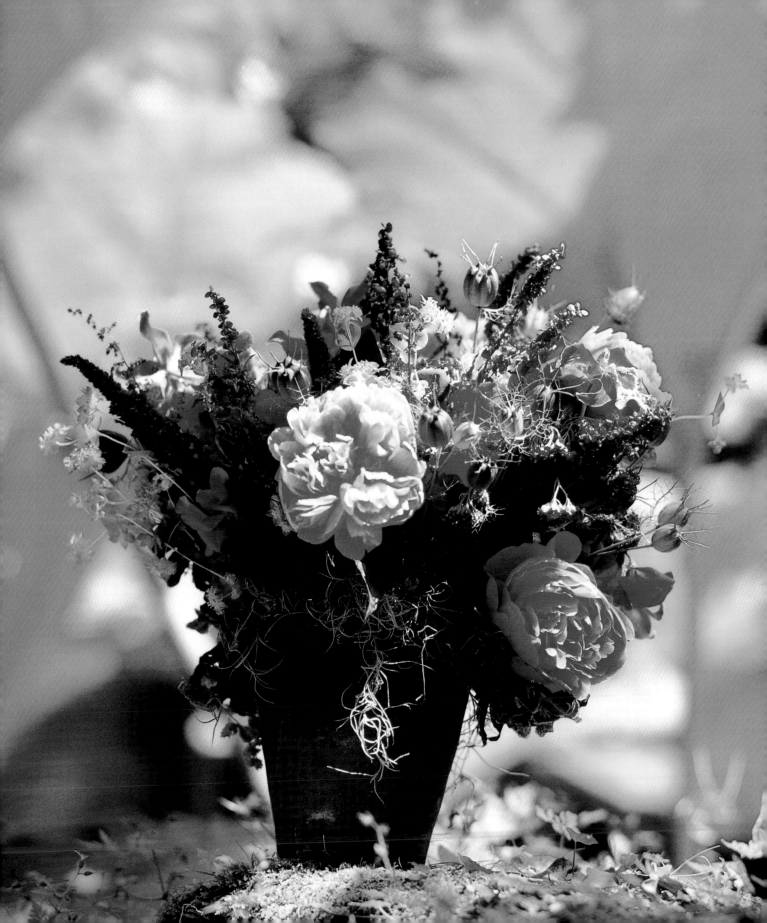

only fast, but also in quite a disciplined way. She often gave the arrangements to her guests at the end of the meal, if they had admired them.

The call for an arrangement for dinner maybe wouldn't come until three or four in the afternoon. Just like the first time, sometimes we simply had to see what we had available from friends who lived locally, what they might be growing in their gardens. Although in some ways it could feel hair-raising, I also knew that these arrangements didn't necessarily have to last, so I would chop flowers and plants around and mix and match quite radically knowing that it only had to look good for one evening.

We sent gifts from the Princess almost every day . . . anything from a small plant or a scented candle to an orchid or a large arrangement. She often sent flowers to people she'd met in hospital who were having a difficult time, but she'd only send them if we were prepared to deliver them personally – it was a way of protecting her privacy, I suppose. Diana particularly loved sending little posies. And she always sent lily of the valley to the Queen.

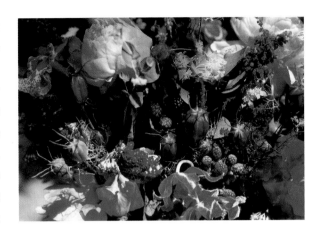

Peonies, Nigella, orchids, blackberries, dock, Lewisia making up the same sort of arrangement as the first one we did for Diana – the same colours, with a different selection of flowers. We were lucky: I later discovered these colours were her favourites. In the background you can see gunnera, an ancient rhubarb-like plant.

WHAT ARE KIP'S FLOWERS? 19

INGENUITY

As there was rarely any brief of what should be sent to the Palace, this gave me the chance to try out all sorts of ideas – such as using fruit, berries, even vegetables. One day we used artichokes and apples, and Diana said she wanted more of these sorts of things!

I also think there has been a real sea change in the way people present flowers and plants. We used to use all sorts of containers for the flowers for Kensington Palace: pots, tins, baskets, bowls, vases, wire baskets. Nowadays, people are much more open to the idea of having a rusty old bread tin planted with some hyacinths sitting on a table in their living room than they would have been five years ago.

Perhaps it's because so many of us now live such busy, giddy, city lives that we respond to something unpretentious; if you can somehow reconnect to simplicity it does make you feel better.

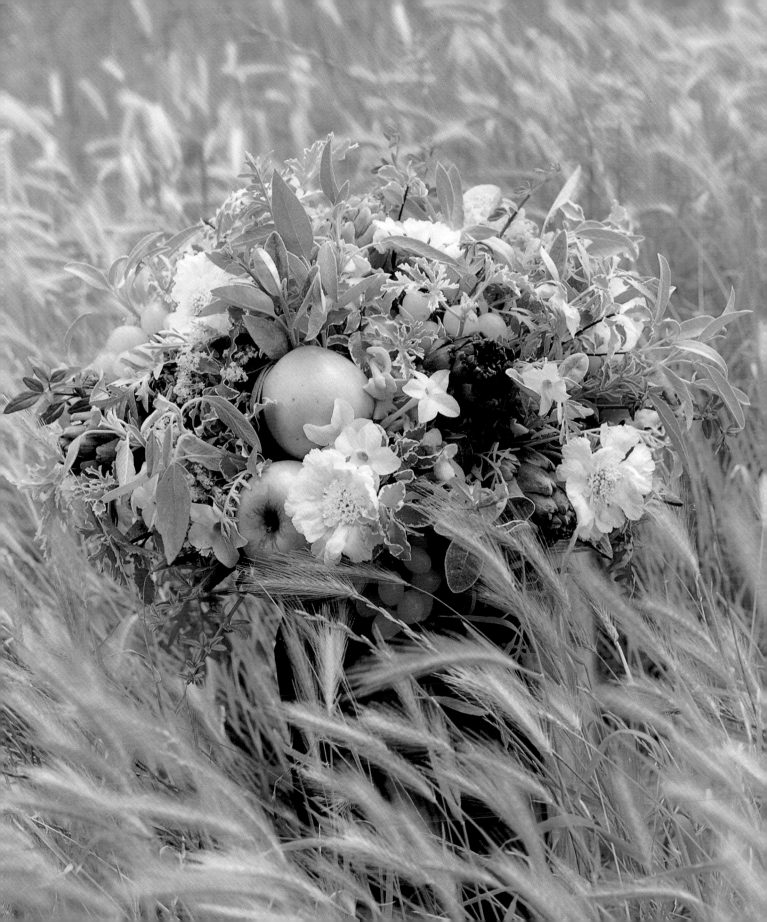

FRUIT AND VEG

A basket I use a lot is this one, made from
coconut shells in the shape of a sunflower. I
would put together three or four arrangements
a week in these, often on consecutive days.
But this one's rather different: it's made using
apples, grapes, artichokes, sage, thyme,
rosemary, scabious, tobacco plants and lemon
geranium leaves.

 It was arranged at very short notice. We
were desperate. It was a bad day for flowers
from the market – there hadn't been a very
good choice available. So we went to Tesco
and bought anything that looked green and
fresh. To make it smell wonderful, we used
leaves from the plants we had in the shop.
The Princess thought it was great and asked
for more of the same.

 I often use vegetables – even potatoes! –
for arrangements. Vegetables were some of the
first things I grew, after all. My favourite were
radishes because they grow so fast, and because
it was so exciting to see the crimson red of
their tops coming through the earth.

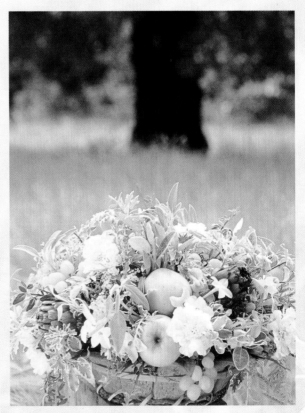

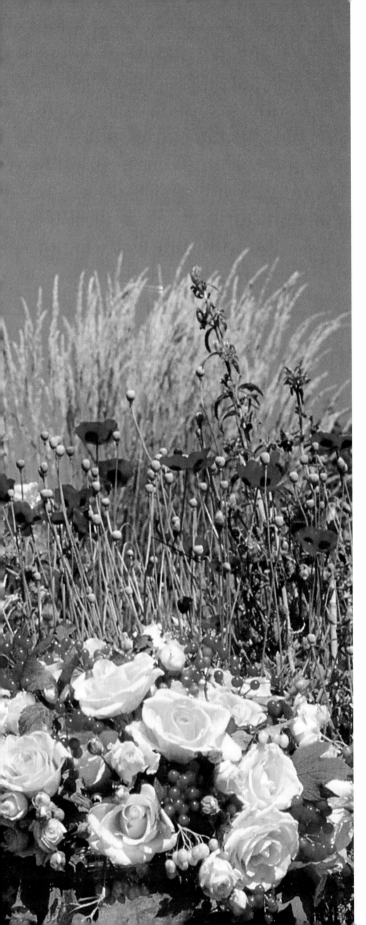

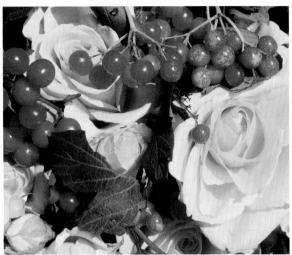

BERRIES AND ROSES

Every week, from the day I started supplying flowers to Kensington Palace, I would discover something new that the Princess liked, from the wildness and freshness of blackberries picked in a country lane through to the more classic shape and formality and simplicity of roses in a silver bowl.

This is a yellow rose and a spray rose, together with viburnum berries, in a very simple but very pretty silver bowl that just lets the flowers speak for themselves. Diana's particular favourites were cabbage roses and Old English roses, not easily available nowadays but more strongly scented and a bit more natural and relaxed than standard roses. There's been a real renaissance of interest in these varieties, and they are increasingly popular in the shop.

BASKETS OF FLOWERS

I used to make loads of baskets and boxes out of bark, stick and twigs myself in the early days of the shop, when I was still working as a gardener and looking after Norman Foster's park. Nowadays, sadly, I don't have the time to make things like containers myself, but I always enjoy putting together these kinds of flowers.

Here I've stuffed a basket with moss and oasis, then scabious, larkspur, *Lisianthius*, antirrhinums, sweet peas and heather. The result is very fragrant, with a sense of wildness and randomness – almost as overgrown as it would be in its natural habitat.

This is typical of the sort of thing Diana might have sent for a birthday or as a get-well present. Sometimes she would also ask for one for her sitting room. If she were sending something out with a personal note, she'd despatch a uniformed Gurkha on a bicycle with the order. He'd bring the handwritten message with her distinctive 'D' on the envelope.

When I first started working at Kensington Palace I had to get used to the staff whizzing about on bikes inside the house! There are so many long corridors it's often the quickest way to get about.

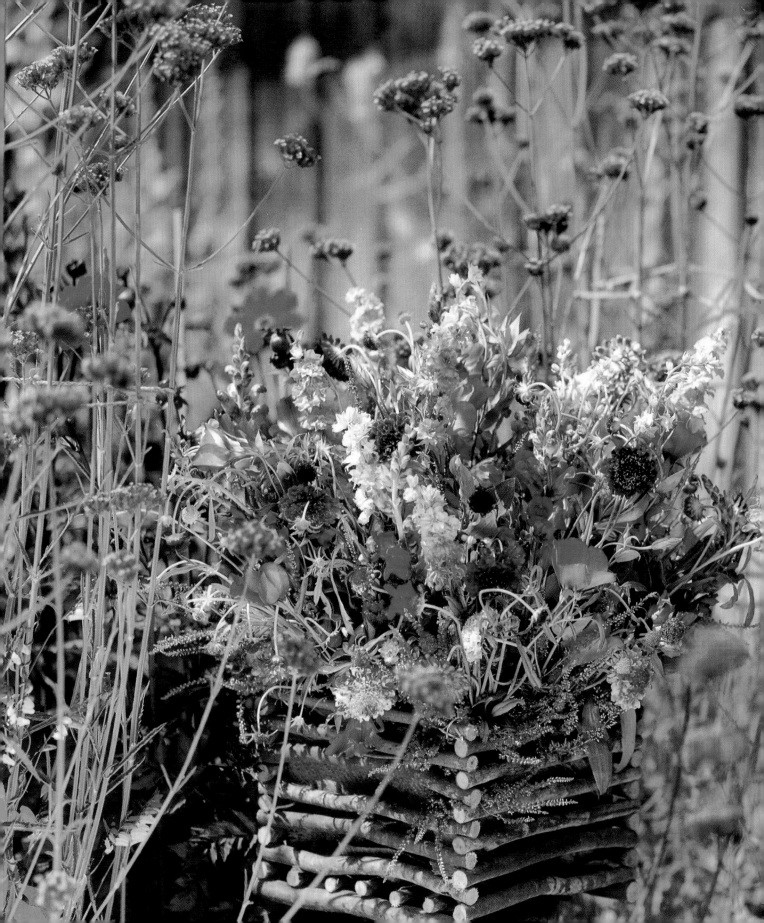

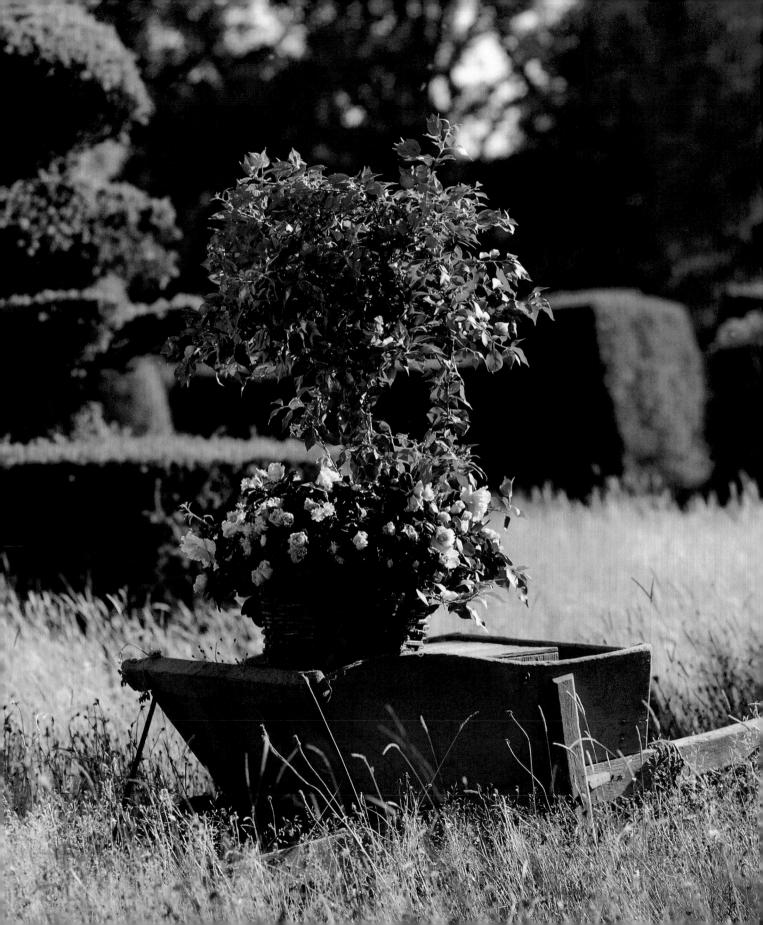

EXOTIC UNDERPLANTING

This standard bougainvillaea is planted in a heavy twig basket and underplanted with pink azaleas and *Lewisia*, an alpine plant. It is typical of something either used to decorate the Palace in a large, grand room, or sometimes sent as a present. We photographed this in Christopher Lloyd's extraordinary landscape at Great Dixter. The garden itself is so magical because, while once it was very formal, Christopher dug up all the roses to let the grass grow up and around the very structured topiary hedges – a beautiful combination of formality and wilderness. I'm sure the Princess would have loved it.

Bougainvillaea is essentially an exotic plant, redolent of the heat of its homeland, and vibrant in its intense colours. The composition here is similar to that of the standard rose underplanted with miniature roses in a terracotta pot you'll read about later, but the effect is quite different because of the combination of plants. The sense is much more relaxed and heady, and when the *Lewisia* petals begin to drop they mix with the azaleas to create a wonderful blossomy bed at the bottom of the basket. It was with these sorts of random splashes of colour that the Princess would bring atmosphere and life to the Palace.

Looking at this arrangement always makes me feel calm.

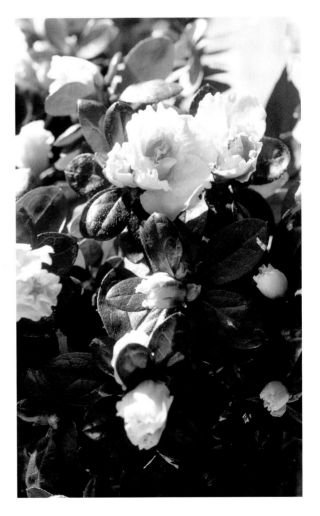

A FLOWER BED INDOORS

Here strongly-scented cyclamen and rose plants are almost stuffed together in a sunflower basket, with a particularly tentacle-like plant, tender lily, and Spanish moss. We would have made this for a dinner table display, or just to bring colour to a corner of the Palace.

The flat, round roses I've used offer an almost horizontal element to the arrangement: the cyclamen is spikier and so more vertical; its leaves add texture. The colour combination is simple but very striking, and it's a display that could easily be created at home as a wonderful centrepiece for any occasion. Made with plants rather than cut flowers, it would last about two months. I often use living plants in arrangements – jasmine and violets work well like this too – and arrange other flowers, fruit and foliage around them.

My idea here was to make it look as though I'd just lifted a bed of flowers up out of the garden.

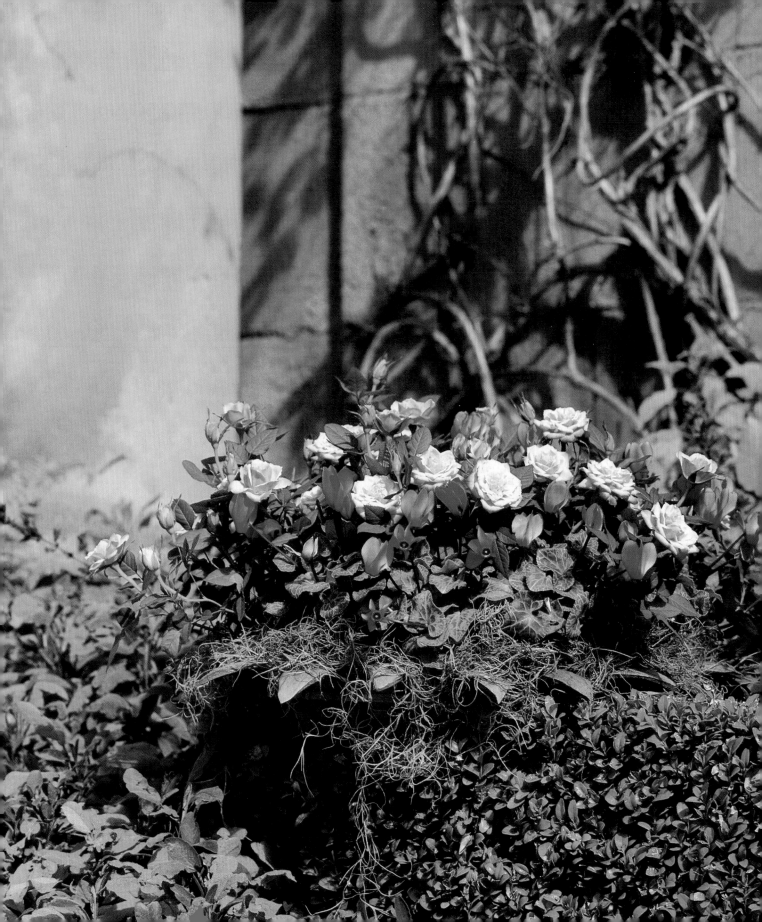

SUBSTANCE AND STYLE

We only ever did two or three arrangements on this scale. They had a strong scent, as we used a very fragrant rose called 'Sterling Silver'. The first time we put it together, it was too small, and I had to go down to the Palace at the last moment to make it larger and more sumptuous – about 4 feet in diameter. The overall effect is very vivid, but there is also a sense of sweetness thanks to all the different shades, from violet to pink, which you don't always get when you use strong colours.

I recently did some more arrangements like this for a wedding. The brief was no arrangements on tables, and no flowers in the corners, so I had to think ceiling downwards. The idea of a chandelier came up in conversation, and I realized that I wanted to recreate that image in some way. We arranged the flowers in thirty wreaths (4 feet and 6 feet wide) which we suspended at different levels from the metal posts of the marquee. The place looked like a floral cathedral! It was spectacular. Lots of people commented on the fragrance, too. One person even described it as 'swimming in an exotic pool of petals and scents'.

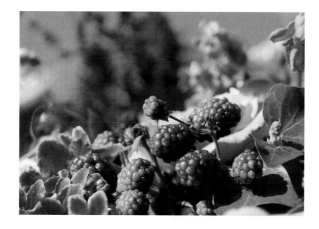

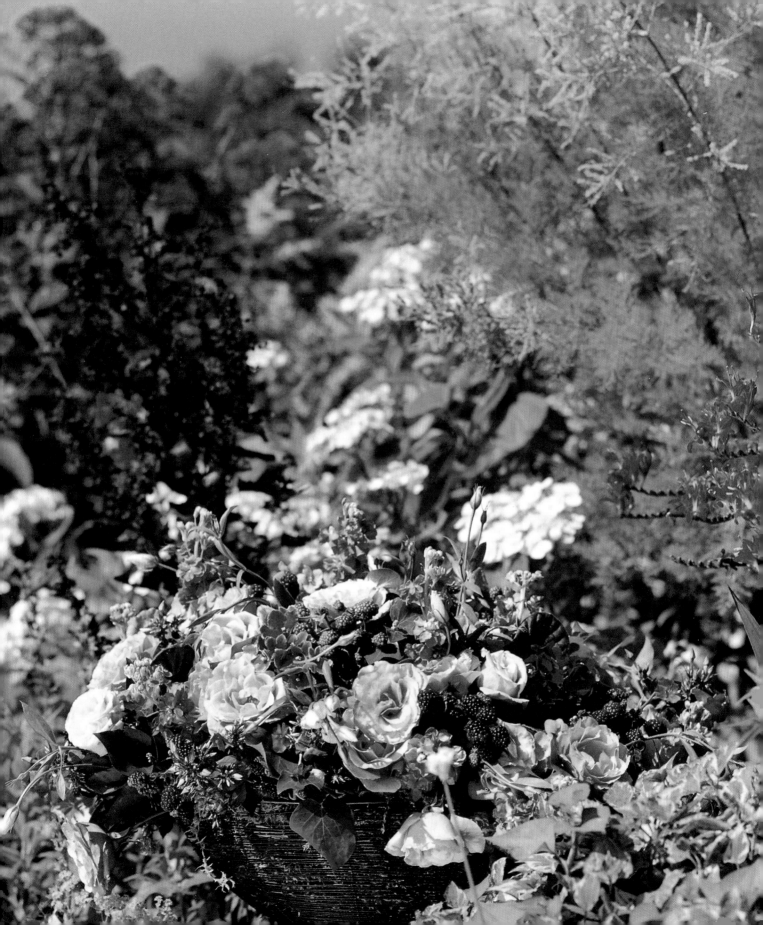

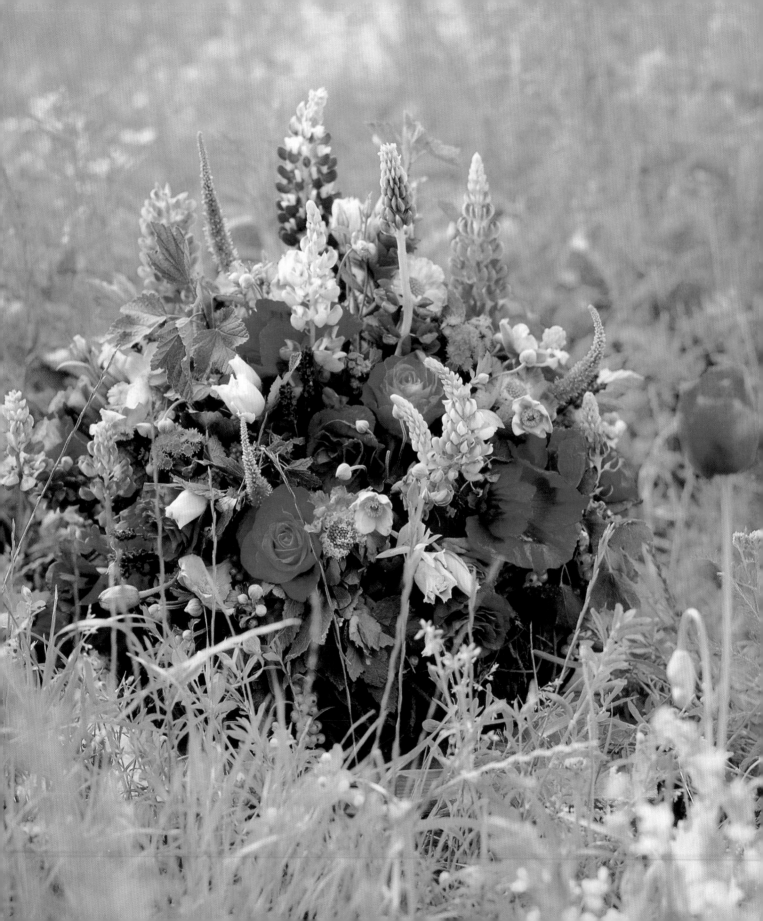

CUTTINGS FROM A COTTAGE GARDEN

Lupins, poppies, roses, scabious, *Lisianthius* and Japanese anemones are all flowers you would find in a cottage garden, and give any room a summery, rustic feel. When I planted my first garden I grew lupins – we didn't have much money to buy plants and flowers but lupins self-seeded and kept on popping up. The Princess enjoyed the combination of pinks, reds and blues that we've used here.

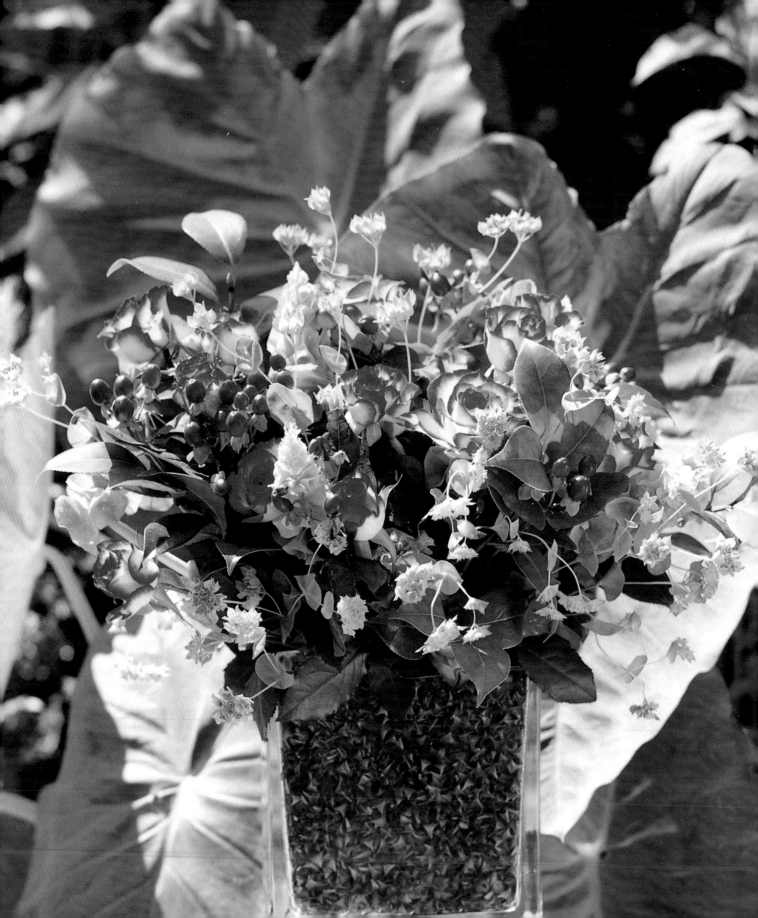

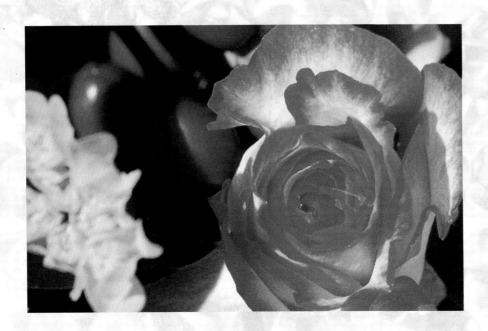

ATTENTION TO DETAIL

When we made table arrangements in glass bowls, we often used to put
the flowers and plants inside a smaller plastic container which would fit
inside the bowl. If you then fill up the cavity left all the way round to
the brim with thorns or nuts, it brings an unexpected extra feature to
the arrangement. Choosing something that relates to the flowers you're
using, for instance, the roses and their thorns here, or picks up their
colours works best.

COLOUR

Colours are particularly associated with seasons and with special occasions. Christmas is the obvious annual event where red and green dominate shops and restaurants – anything from Christmas cards and wrapping paper to napkins and all kinds of decorations.

Everyone has their own personal associations with colour and a lot of people who come into the shop have very strong views about what colour goes with what season and, more importantly, with each other. I try to use colour in as varied a way as possible and, particularly at the beginning in the shop, I worked hard to overcome any preconceptions I'd had about what colours should be put together.

I think almost all flowers, whatever their colour, look good together and I think that colour, like smell, can change and enhance mood and atmosphere. There is a wonderful sense of vibrancy about a big bunch of flowers with strong colours. It's almost guaranteed to make someone feel happy and uplifted.

WARMING UP

This arrangement in a sunflower basket has sunflowers, roses, dill, *Bupleurum* and a kind of *Leucadendron* called, appropriately enough, 'Safari Sunset'. They're colours most people choose in the autumn, not only mirroring the colours of the season, but also suggesting warmth and vibrancy at a time of year when the first chill is in the air.

After lunch, if Diana hadn't given the arrangements to the guests to take home with them, Paul would often dismantle them, splitting them into bunches to put into small square pots, tiny vases or even inkpots to be dotted around her sitting room.

THE MEANING OF PINK

Of all these flowers arranged in a cylindrical vase, the overwhelming colour is pink. It's a colour we all associate with sweetness and romance. If you're carrying a bunch of pink flowers anywhere people will always comment on it – it is as though they sense there's a story to tell. Pink always makes people smile.

Packing these peonies, roses, nerines, *Bouvardia*, *Alchemilla* and phlox tightly together like this really shows off a whole variety of different shades and textures of pinks; small delicate flowers combining with big, almost blowsy ones. The green leaves and stems of the different blooms give definition to the various tones. Diana would put an arrangement like this on a little table in the hall or sitting room and gradually, as the flowers relaxed, they would start to intertwine. It always looked very pretty.

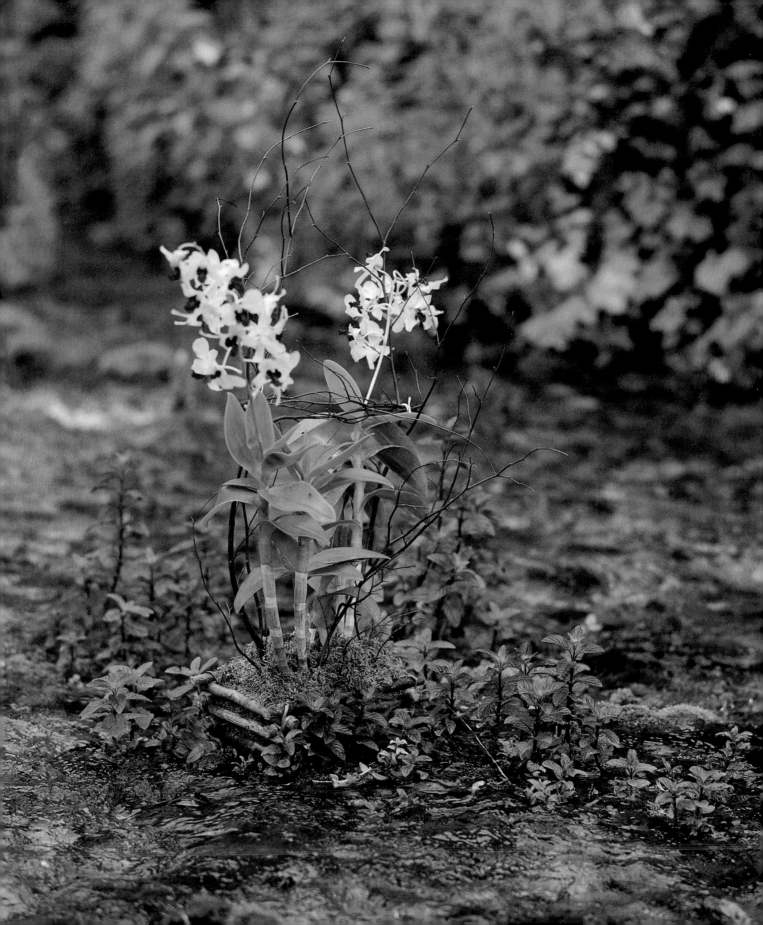

A HINT OF LIME

There are at least ten thousand species of orchid and they offer a huge spectrum of colour. Orchids can be white, pink, green, purple, blue and red. Sometimes they are a mixture of two or three colours and are often patterned with flecks, spots and stripes. They are always extraordinary to work with and even in the simplest arrangement they look wonderful. These lime-coloured blooms have dark crimson centres, and because of the way their leaves grow at right angles, the delicate flowers have a very structured, definite means of support, yet remain the essence of simplicity.

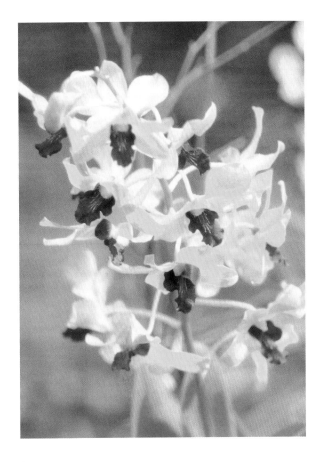

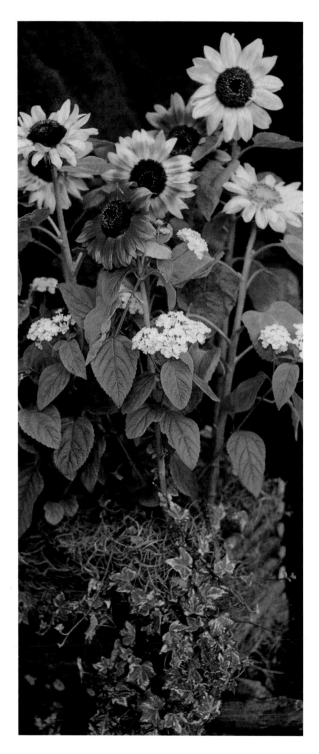

A LOT MORE YELLOW

I think these sunflowers planted in a twig basket with lantana (which is very scented but very poisonous!) convey a sense of carnival-like happiness. The colours are fiery – yellow, red, orange and maroon.

I don't very often have cut sunflowers in the shop, I much prefer them as plants. They last longer, and have much more character. Although bold, they also offer great subtlety and variation.

Sunflowers are great to grow in a garden. Hardy and reliable, they can grow to an enormous height – children particularly enjoy watching them shoot up. One of my favourite sights is a field full of them in Spain.

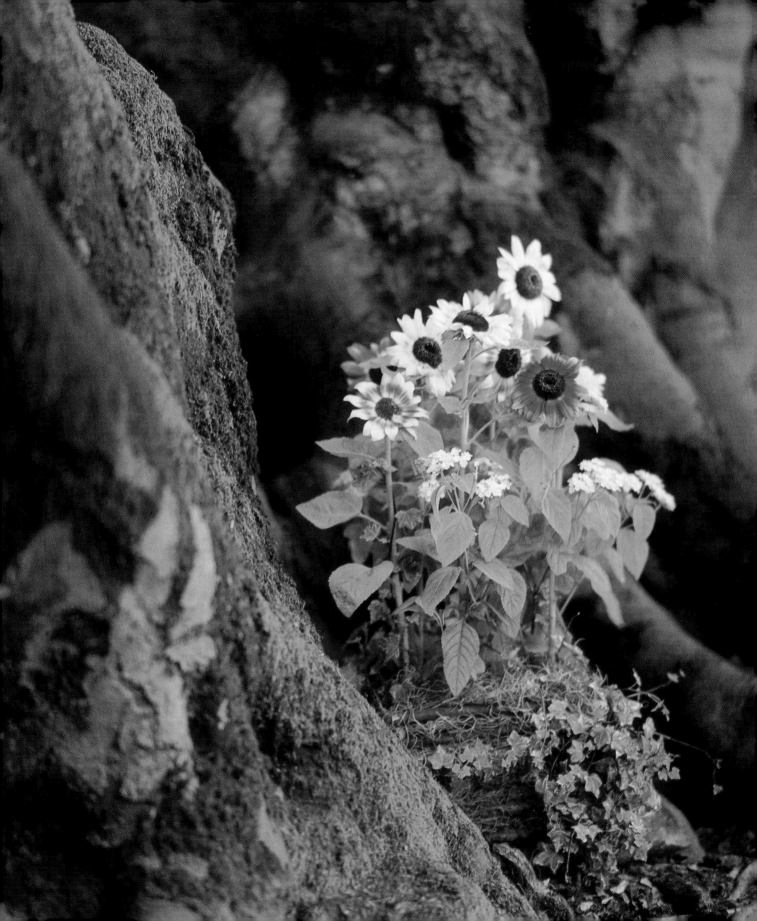

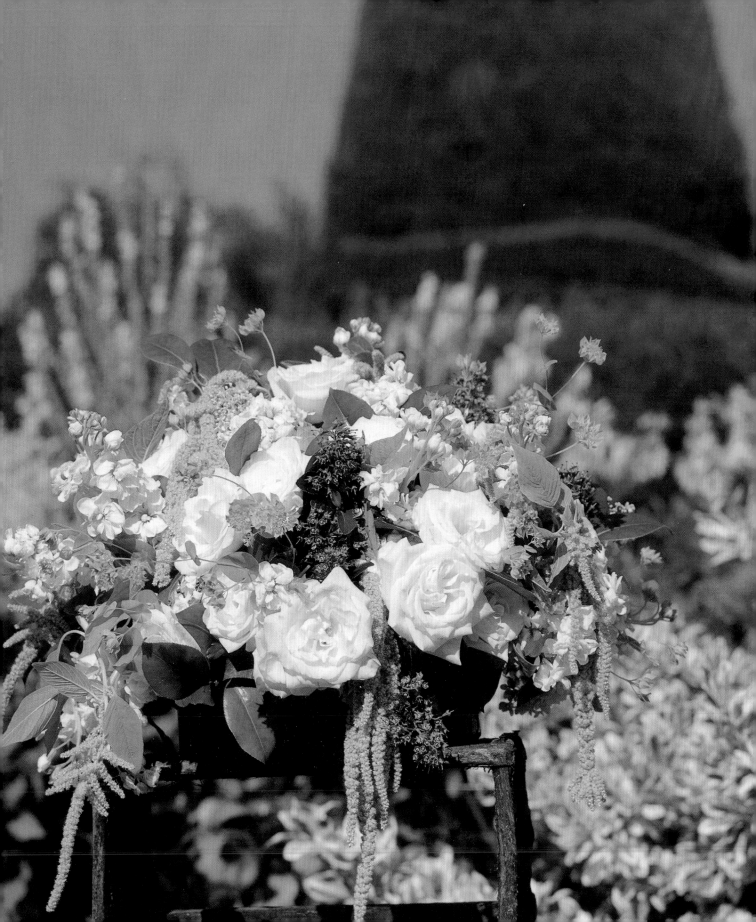

COLOUR ON ITS OWN

You can get carried away with colour combinations so it's refreshing
to come back to using just one. Some of my clients are architects and
they often particularly like single colour arrangements, with their clear
graphic identity. Interestingly, using different shades actually makes the
visual purity more effective.

Here I've used cream roses with white roses and cream stocks with
white stocks. But instead of using different whites with creams, you
could try a subtle variety of blues, to get the same sort of pure but
vibrant effect.

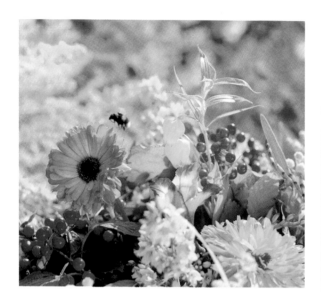 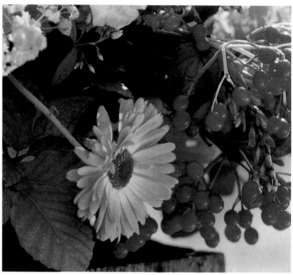

COLOUR FOR A SUMMER'S DAY

I was carrying this basket of marigolds, mimosa, viburnum berries, *Alchemilla* and Chinese lanterns across the car park at Kensington Palace when Diana spotted me. She had just waved someone goodbye, and beckoned to me to come through the main entrance with her rather than use the tradesman's door. We started chatting about the arrangement, and she joked that these were the sort of colours that people should use at funerals to take away some of the sadness, they were so cheerful. The flowers for her own funeral were very beautiful, and will of course endure in people's memories. I did a lot of the arrangements myself, but everyone requested white.

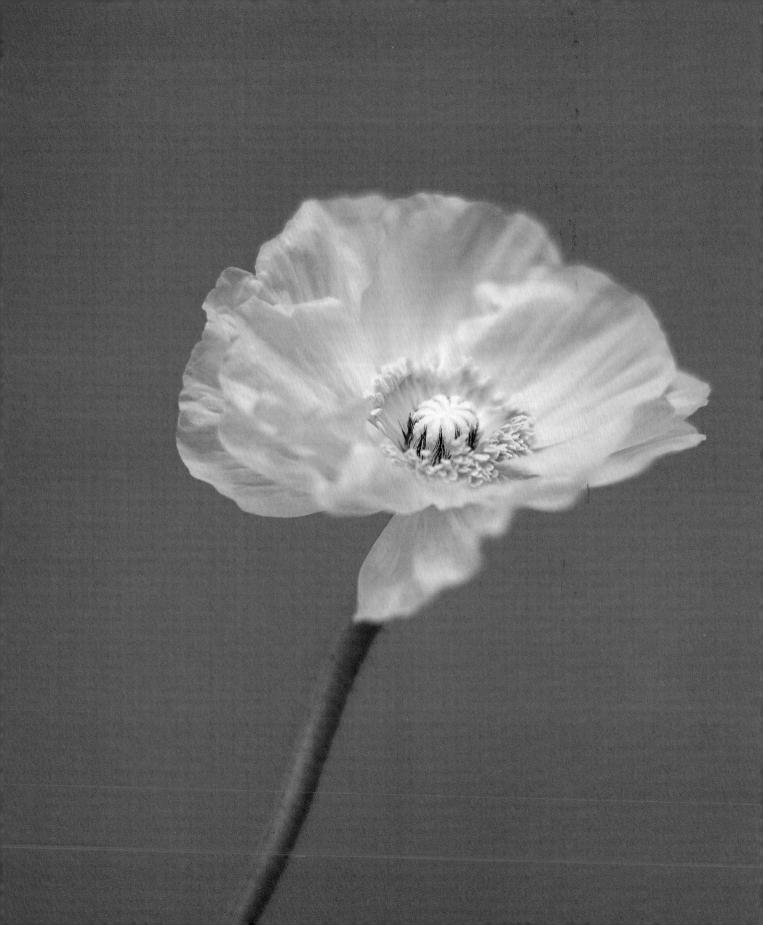

SIMPLICITY

It soon became clear that 'The Boss', as Paul Burrell always referred to the Princess, did not like large or grand traditional displays. When I wanted to send her some flowers for her birthday, Paul recommended something small – that way she'd want to hang on to them herself. I simply sent a tiny bunch of fritillaries – and she was delighted. You can see them on page 4.

While I used to arrange big vases, 2 to 2½ feet high, two or three times a week, the Princess preferred quite simple things in them, such as a large bunch of creamy coloured stocks, 'Casablanca' lilies, or a mass of peonies or sweet peas. Always, scent was an overriding factor in the choice. I still provide very similar kinds of flowers for several clients on a weekly basis.

The more flowers I did for Diana, the more I learnt about what she liked – and 'the simpler the better' seemed the golden rule. Sometimes Paul would add his own touches, like sprigs of blossom from the Palace's private garden.

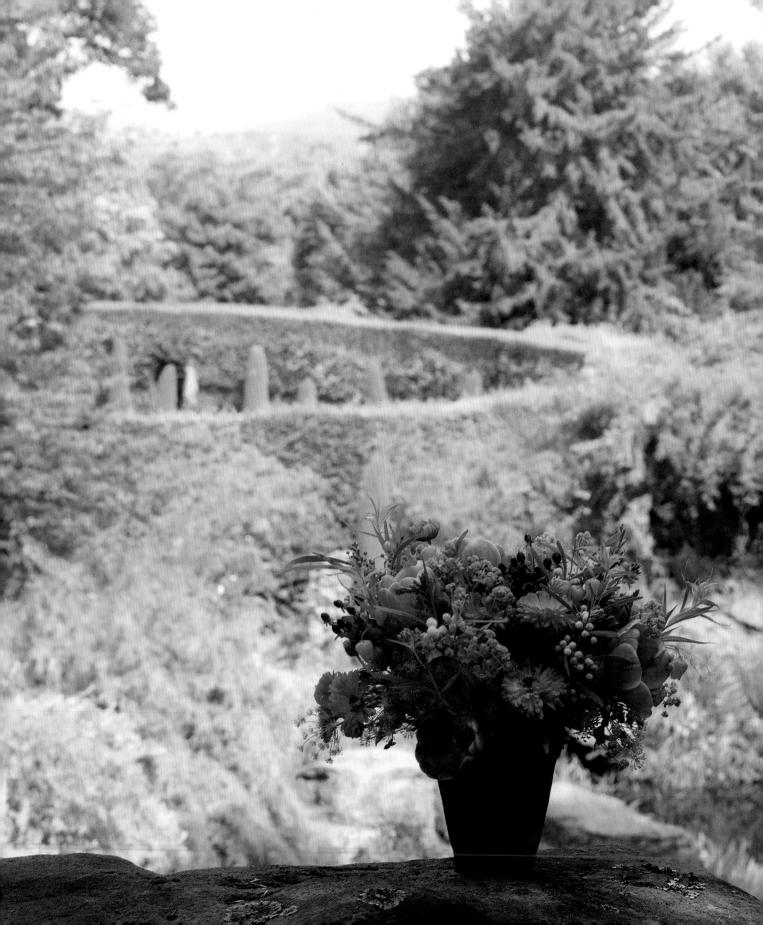

HAND-TIED FLOWERS
IN A TERRACOTTA POT

This is really a variation on that first flower arrangement I did for the Princess. While using the same sort of pot and composition, I would vary the flowers and often used tulips, marigolds and mimosa. The strong, happy colours seemed to make them good for gifts, and I sent out lots of pots like this.

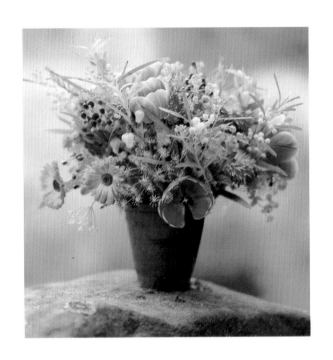

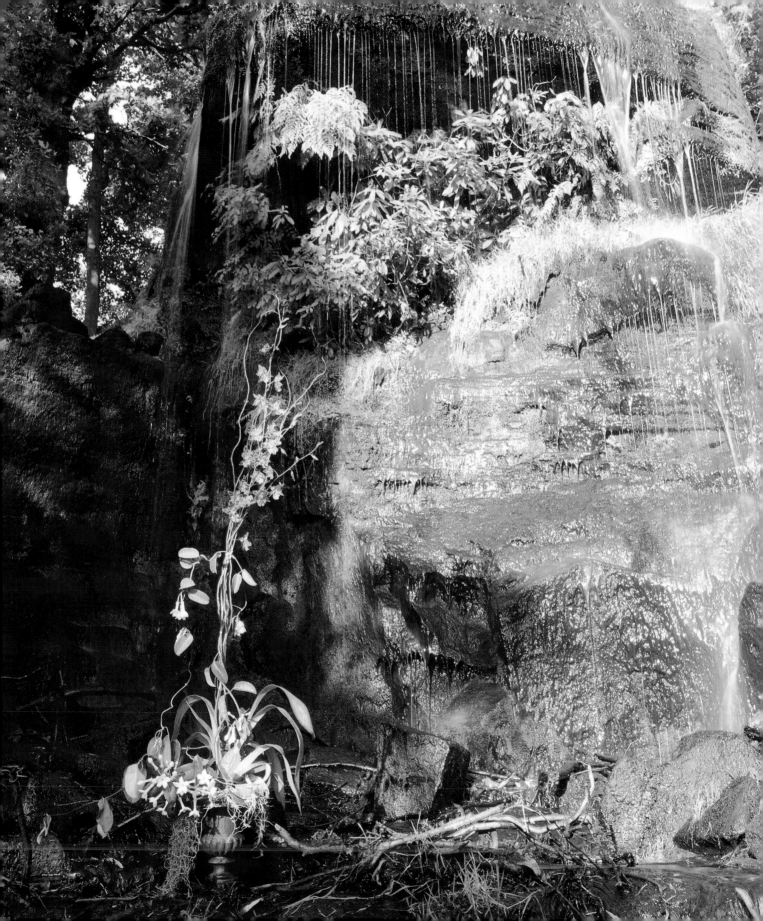

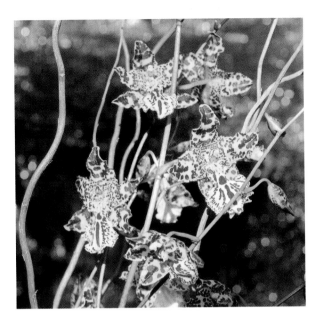 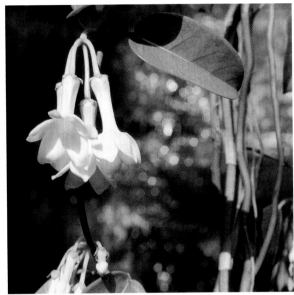

VISUAL PURITY

This orchid is planted with a stephanotis, making it climb around its stem. I love the combination of the visual purity of the orchid – also so lushly perfumed – and the wild, rambling nature of the stephanotis. For some reason I think orchids always look much better in metal or iron pots, rather than terracotta. Put them anywhere, in any kind of room, and they bring a sense of beauty and grace to their environment.

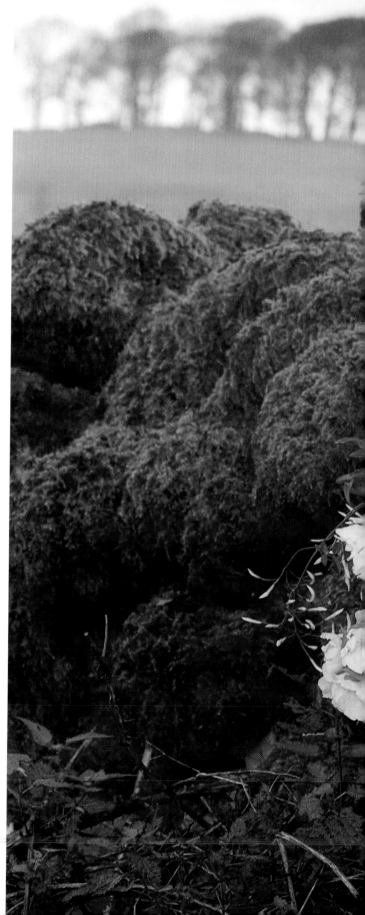

LIGHT, WHITE BEAUTY

For this planted winter basket I used all whites – jasmine, cyclamen and primulas – surrounded by moss. Although it's entirely composed of plants, it has great fragility and beauty, and in various forms I did it time and time again for the Princess. It's something she would have kept rather than sent, and it would have lasted a long time – maybe a month or six weeks. Both colleagues and clients have commented that this is one of the best arrangements that I do.

This particular photograph was actually taken on the way to doing something else. I saw the mossy wall out of the car window, jumped out and arranged it on the spot. I loved the freshness and beauty of this particular spot, and in response wanted to create something immediately.

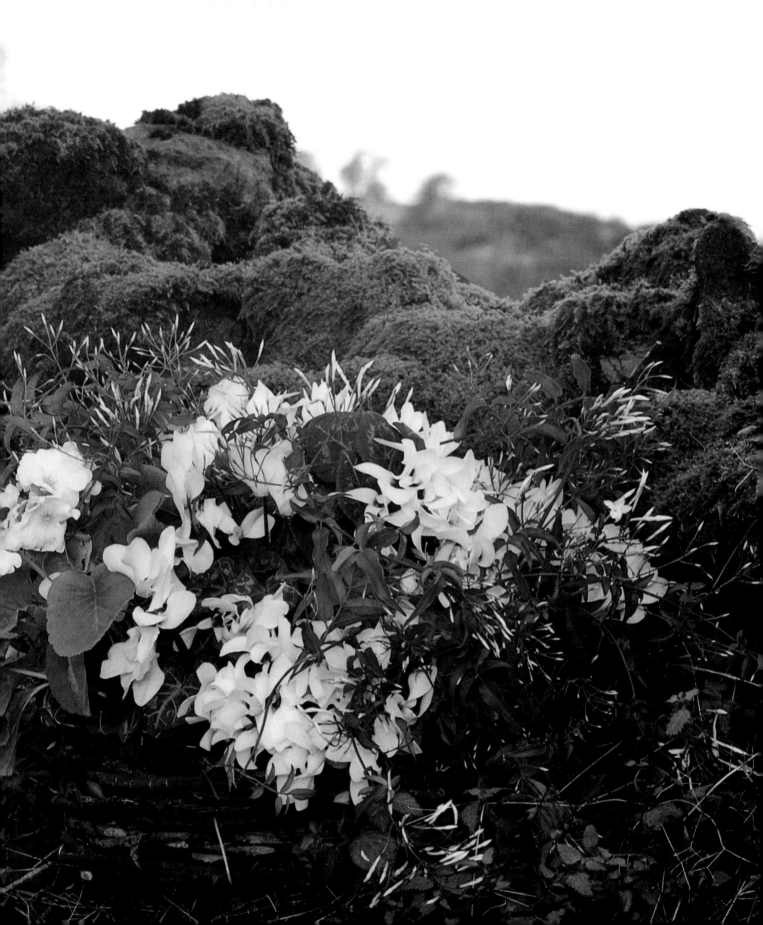

SCENT

I discovered quite quickly that Diana particularly loved distinctive smells. If an arrangement wasn't strongly scented, it had to have something else pretty powerful going for it!

Thus the fragrances of the flowers I used often became a significant factor in the flowers' choice. If something wasn't naturally strongly scented, we would add herb leaves such as sage, mint or rosemary, or at Christmas sprinkle the whole thing with spices, such as cloves and cinnamon.

HERBS AND ROSES

This is one of my favourite sunflower baskets. The flowers could be any combination of berries (the Princess loved anything with berries – blackberries, pyracantha berries, holly), ivy, hyacinths, mimosa, roses, guelder rose, fennel, rosemary and thyme. When I learned about Diana's penchant for a powerful scent, I started to add more and more herbs, both cut and growing. It's not really so unconventional; florists use wild plants and flowers in even quite formal arrangements. But the scent is the added bonus here.

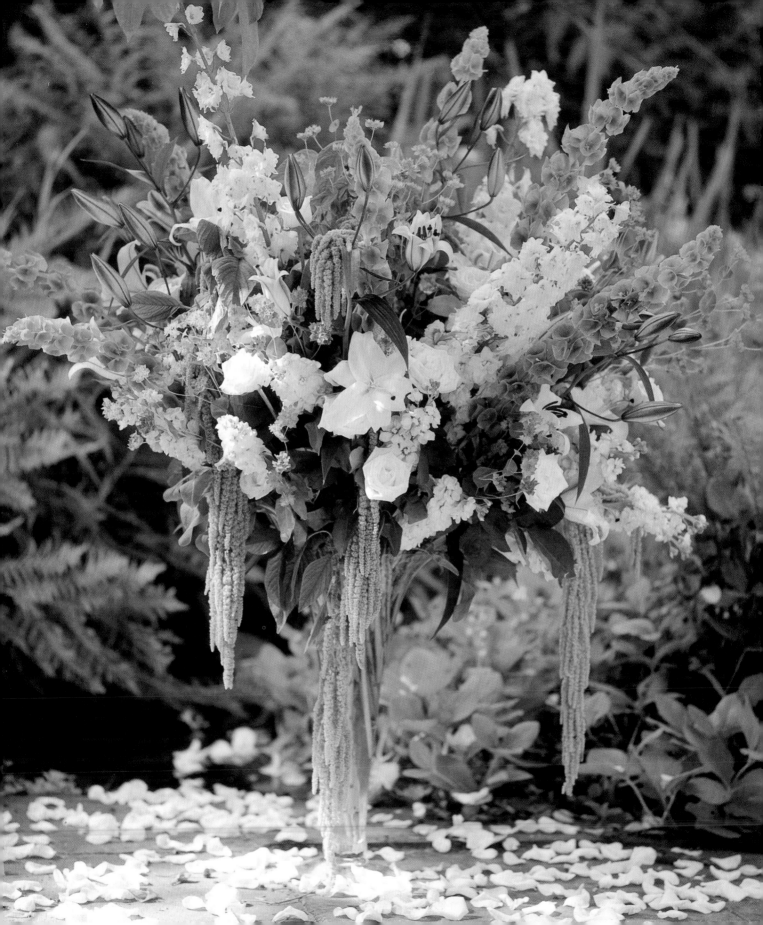

INTENSITY OF FRAGRANCE

'Casablanca' lilies, stocks, delphiniums, Bells of Ireland, *Bupleurum*, *Amaranthus* and white roses would be arranged in large vases in the Palace – there would almost always be two or three on display. These were flowers especially selected for the intensity of their combined fragrance, and most of them are available all the year round.

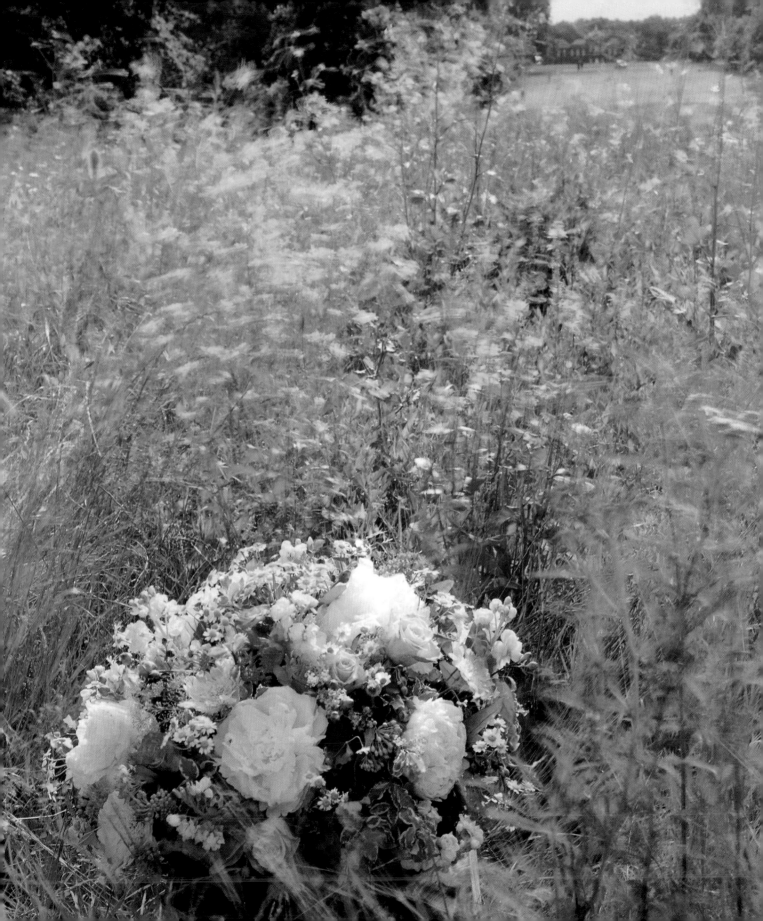

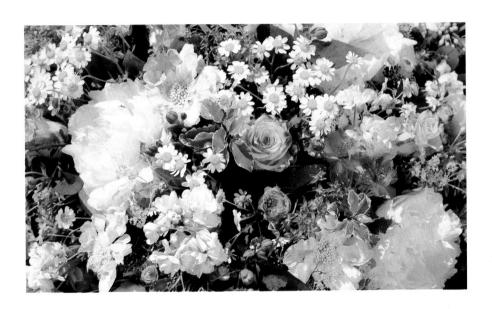

DINING ON SCENT

I was asked to make table displays for lunches and dinners almost every day. I would always ask who the guests would be, and Diana's office would usually tell me. I'm afraid I didn't alter the arrangements accordingly – I was just nosy! But it was helpful to know how many people were invited – it could range from two to twenty. The table was round but could unfold and the displays were 2½ to 3 feet long, or even bigger if the table was fully extended.

The peonies, camomile and orange roses used here are all very strongly scented, and would have made a considerable sensory addition to the atmosphere of the room. It's typical of the sort of table arrangement I used to prepare.

You can actually see Kensington Palace in the background of this photograph.

FRESHLY CUT

I made up this basket of roses, sweet peas and anemones from a twisted vine for Diana's sitting room. It's the scent of the sweet peas that really stands out – but the whole combination is light and airy and delicate. There's also a sense of immediacy – I wanted to convey the feeling that the flowers have literally just been picked from the garden.

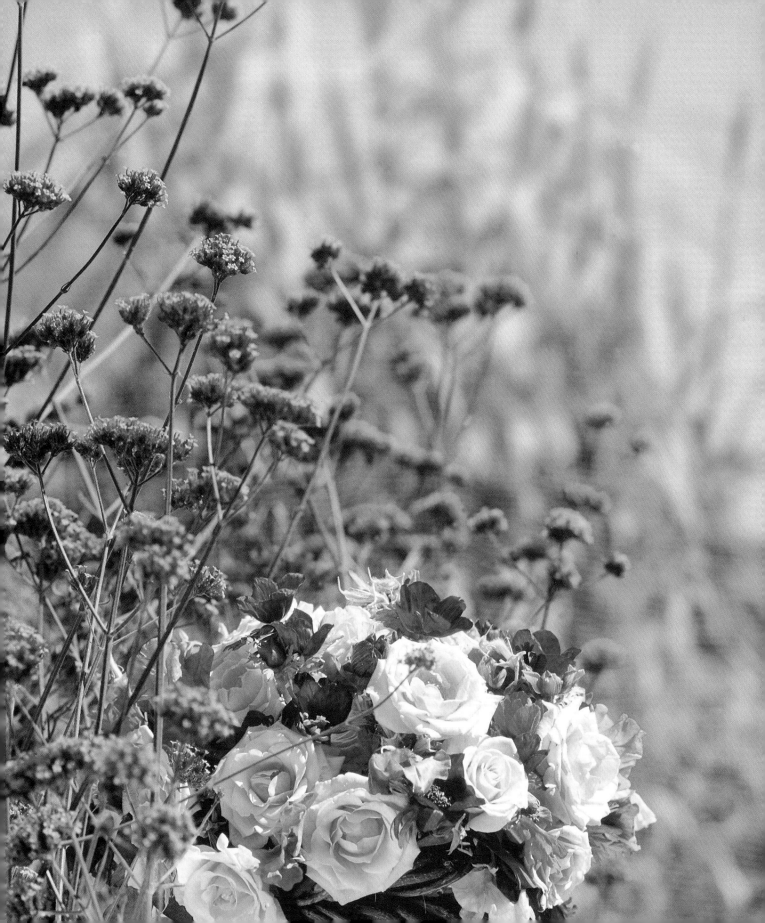

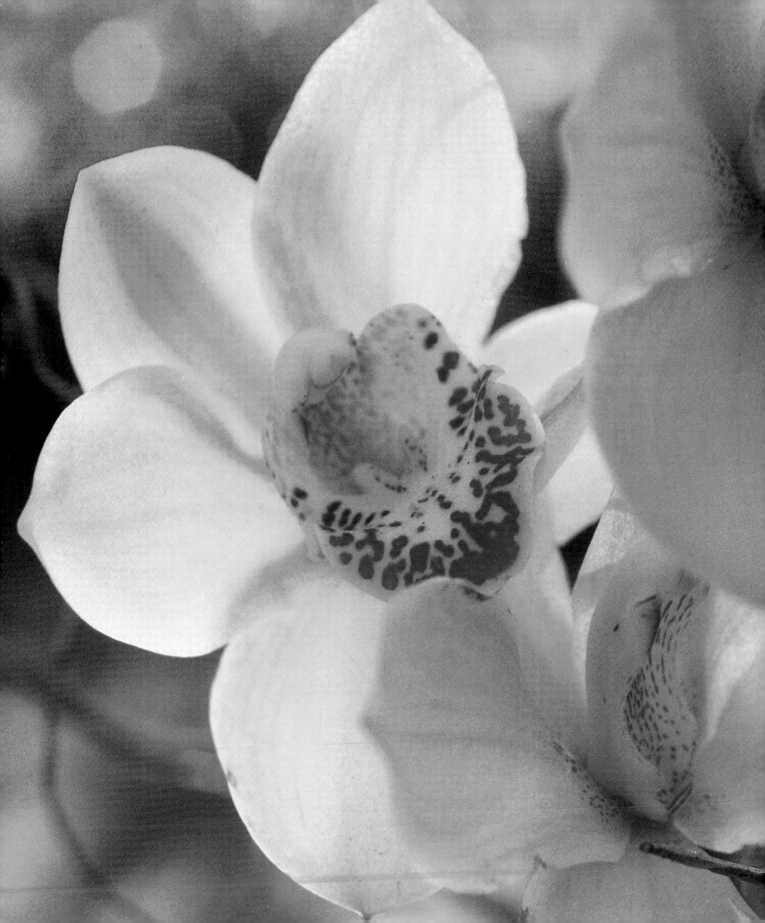

FAVOURITES

It's a curious feeling to know that someone else shares your likes and dislikes to the point where you never really have to discuss it – you just both know. I did sense that connection with the Princess of Wales. People who come into the shop generally favour peonies, lilies, daffodils and sweet peas, but price always plays an important part in the final decision!

I find it really hard to choose my own favourites, but they would probably include peonies, forget-me-nots, lily of the valley, tuberoses – the latter for smell not look – and sweet peas, because they smell so sweet and look so delicate. If I had to make one overall choice it would have to be orchids, probably because of their elegance and their incredible versatility.

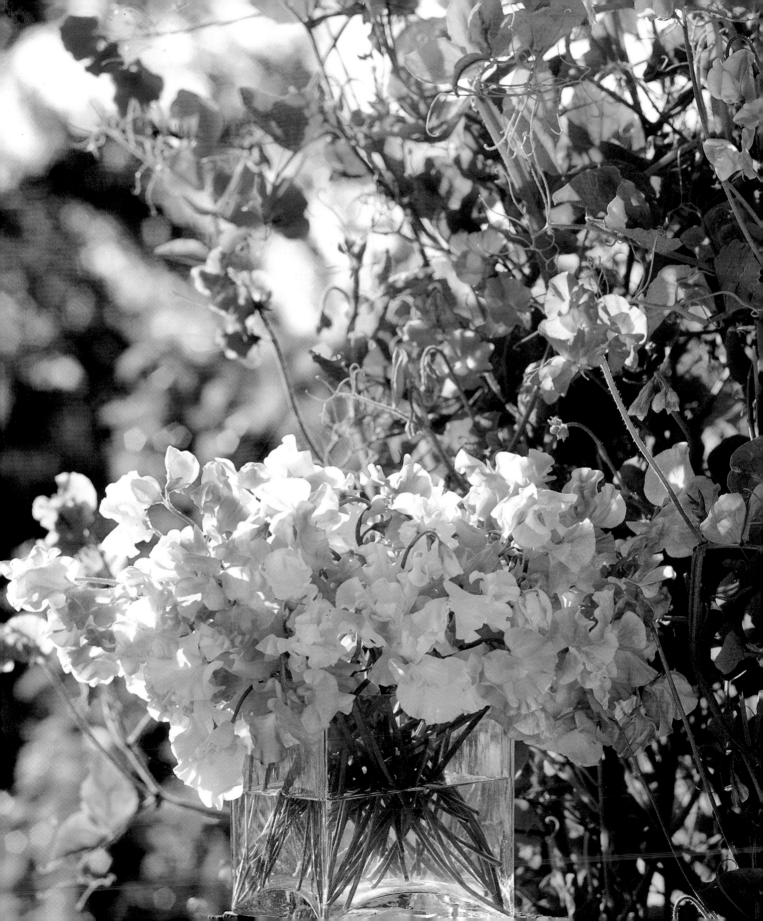

SWEET PEAS

The Princess was particularly fond of sweet peas. They had played a large part in her early days. They were grown at Highgrove, and she had included sweet peas from the garden there in her wedding bouquet.

I would go to Kensington Palace on a regular basis and dot bunches of them around the place, perhaps on her writing desk, or even in the bathroom. They looked best in chunky little square vases, even inkpots. Although you can get them all year round, English sweet peas in season – July and August – remain unbeatable. They are easy to grow, too, and miraculously the more you pick them, the more they flower.

ROSES

Everybody loves roses. They are the quintessential English plant, and there's always a huge variety available. They look sumptuous and intense, but I think also quite scruffy if you get the right ones at the right moment. I would always choose roses I could pick from a garden; their smell is sweeter, and even though they don't last as long as commercially grown roses they have great beauty and charm, either by themselves or with other flowers. Enormously versatile, you can mix them with virtually anything. They'll always be associated with the Princess.

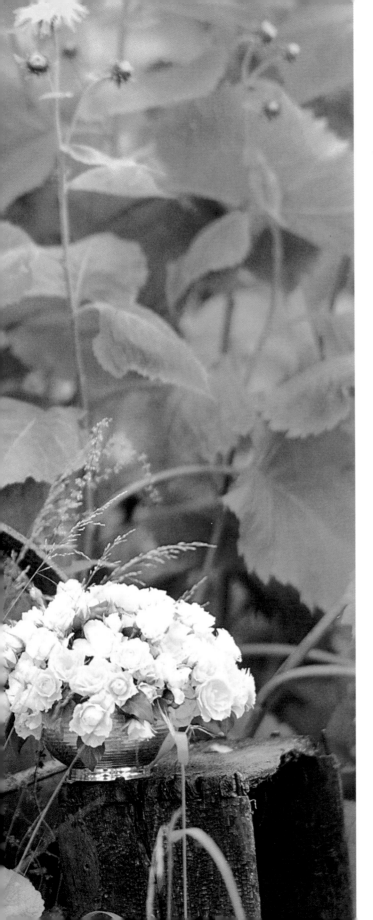

'STERLING SILVER' ROSES WITH WHITE AND YELLOW MINIATURE ROSES

It's the scent of 'Sterling Silver' roses that makes them so exceptional. It's pungent – it always makes me think of those Parma violets I used to buy at the sweetshop when I was a kid. In fact, on their own they're not exceptionally pretty; they're a flower for other senses than the eye. Just a few would sweeten up the whole apartment. They open quickly, as if showing off, but they last for days.

In the smaller bowl are miniature roses. By contrast, these have no scent, but great beauty in their minute perfection: almost like a posy. We'd put an arrangement like this in a guest room. After the first time we sent one, we heard that Diana wanted us to make them up fairly regularly. She'd often want one on her writing desk. Sometimes we'd do them for bathrooms, and they last a week to ten days. They are simply delightful.

Paul would also pick cabbage roses from the garden at Kensington Palace and we'd use them with wild flowers from the shop to create a centrepiece for lunch or dinner. They have a strong, sweet smell and the bud opens really quickly. The only drawback is that they don't last particularly long.

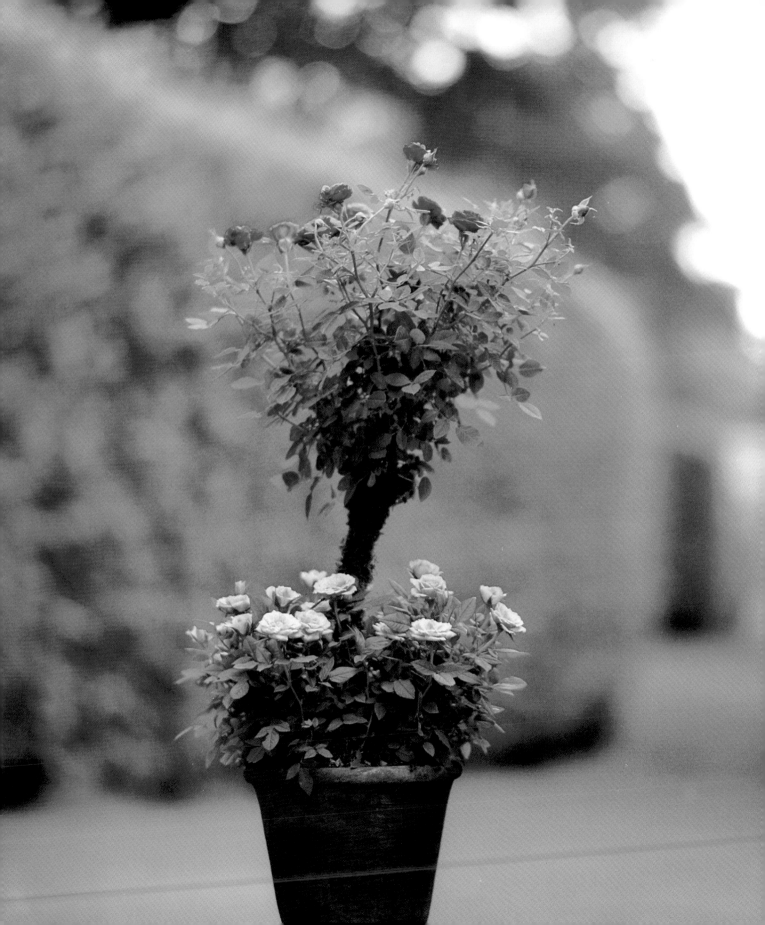

STANDARD ROSE

This is a whole plant, in a large Victorian terracotta pot. I've underplanted it with miniature garden roses. Set here against the hedges of Chatsworth it all starts to look a bit like a scene from *Alice in Wonderland.*

I've intertwined two standard roses to give the arrangement body, and also covered the stems in moss, to create a 'trunk'. The underplanting of miniatures softens the structure and formality. It's actually very easy to do and looks exceptionally beautiful when all the plants are in full flower. The idea was to make it look as though the pot had just been brought in from a terrace or garden.

We often provided standard roses for the Kensington Palace hallways and corridors. A few lucky people also received them as presents!

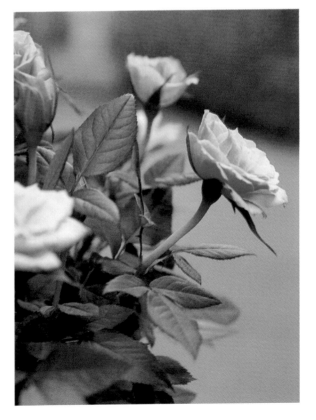

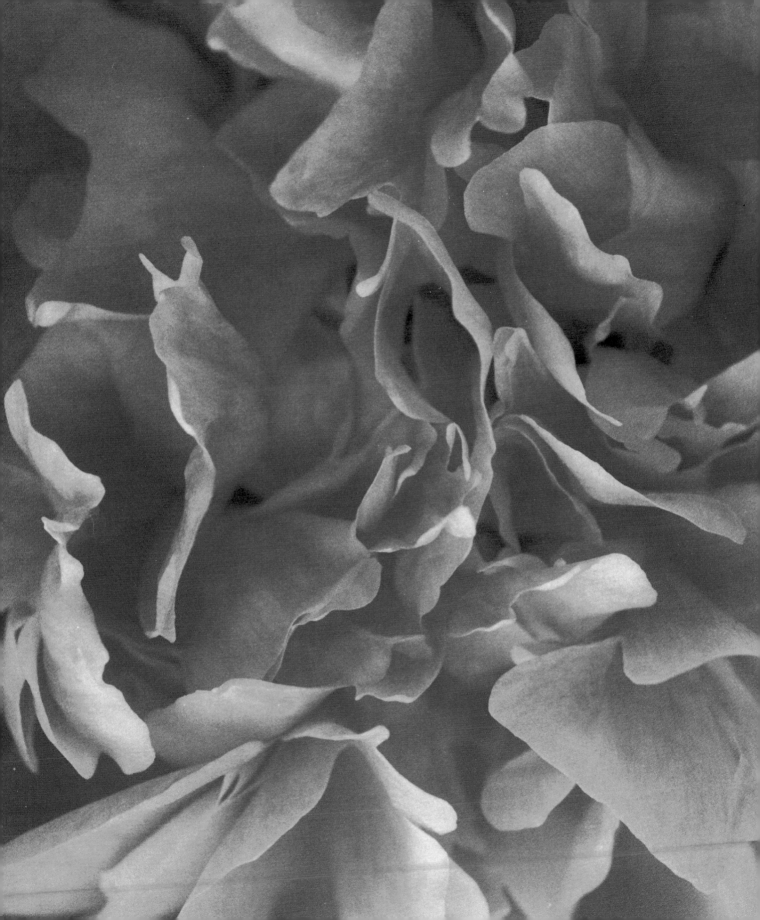

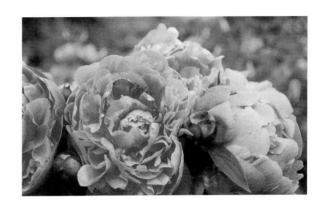

PEONIES

Traditionally, peonies are associated with the months of June and July, when they're most outstanding – although now you can get them in November and December, too. Diana was passionate about peonies – interestingly, her birthday was in July – along with hyacinths, sweet peas and stocks. Any arrangement I made with peonies for her was always a success. We'd make full use of them when they were in season, either by themselves in large bunches, twenty or thirty at a time in a big glass vase, or wrapped into other arrangements, big or small.

I love them for their beauty and fragility, and the way they start as a tightly furled ball, then bloom in a very intense, beautiful way before dying quite quickly. Most people seem to love them. I also think there's a great sense of romance about them; as a friend of mine says, you can tell someone really loves you when they send you a taxi full of peonies!

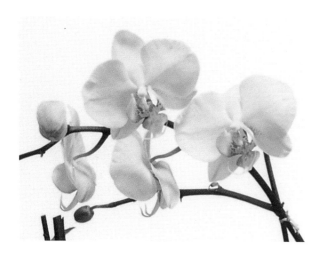

ORCHIDS

I love the elegance of orchids – you can look at one every day and still find something different in it. They can last two or three months in the right place, and the best way to look after them is to ignore them for most of the time, just watering them once or twice a week. They don't grow in the soil itself; their roots are on the surface, and take moisture from the air around them. The roots look great in their own right!

A little like champagne, orchids have a special, celebratory character. They are also incredibly versatile. Because they grow naturally in trees you can do all sorts of things with them, like tie them to the sides of baskets, or leave them on top of an upturned pot. They were always a particular favourite of the Princess's, either to send as a present, or to display around the Palace in large planters.

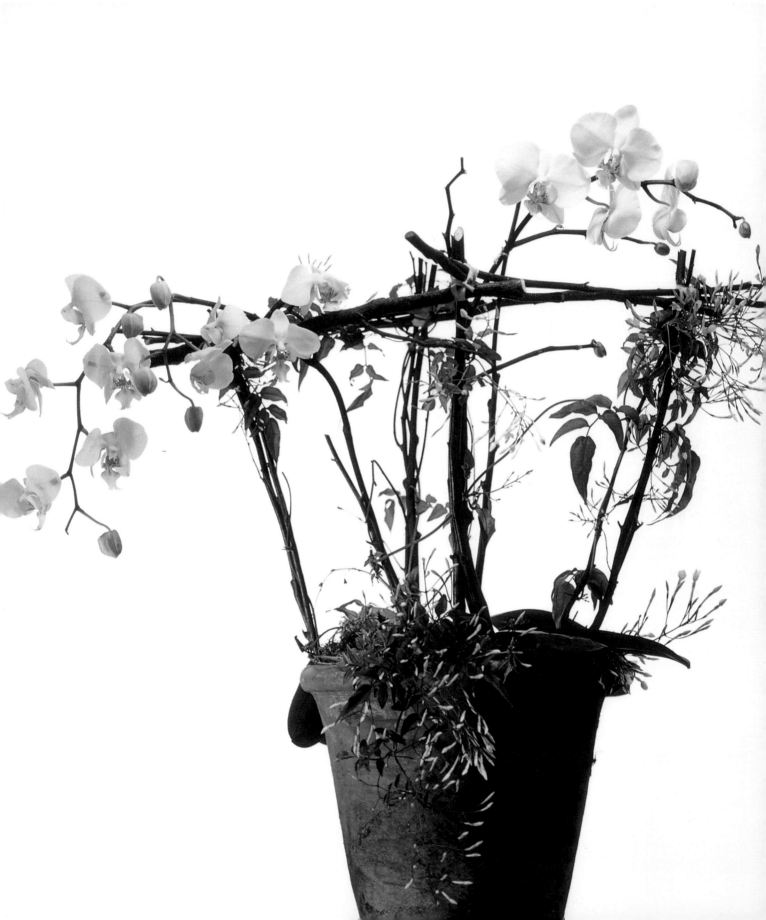

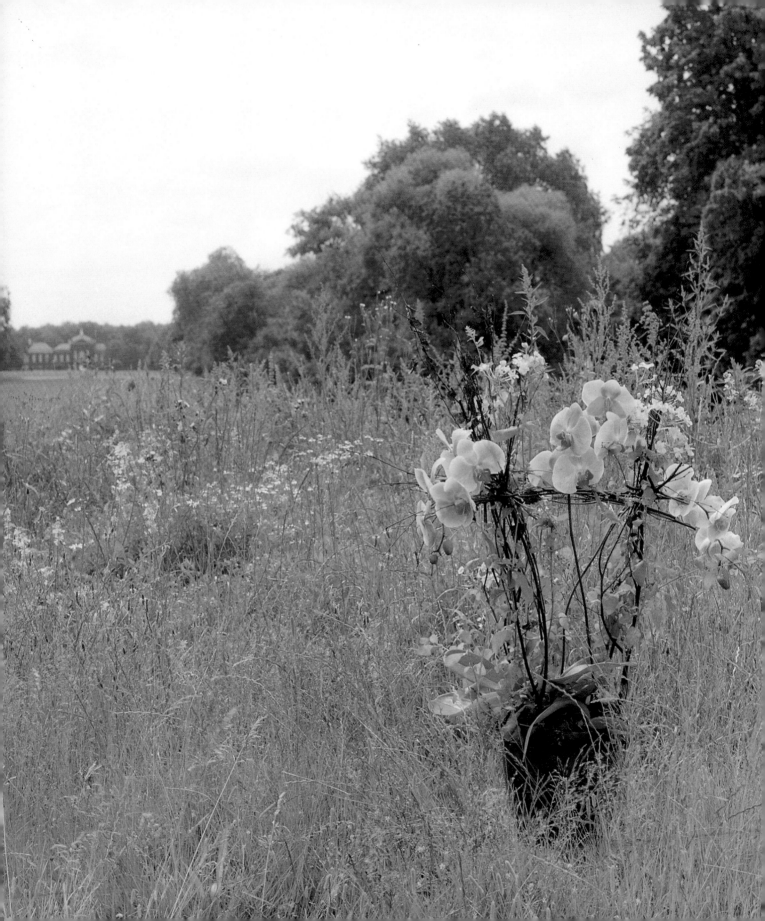

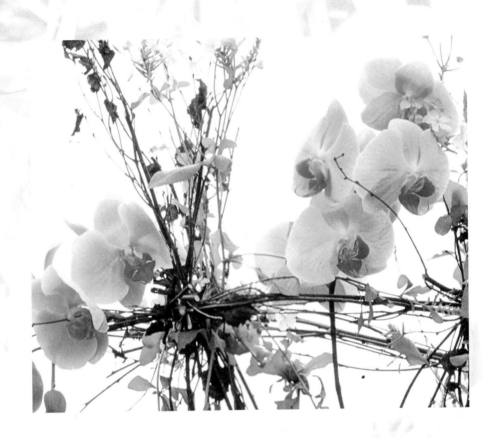

PHALAENOPSIS

Here three *Phalaenopsis* orchids have been planted in a Victorian
terracotta pot, supported by a cage of silver birch twigs. Creeping
through the birch twigs is plumbago, interplanted with the orchids.

TIGER ORCHID

Orchids in the wild will sometimes grow on the side of trees or hang from branches. I wanted to recreate an echo here of the orchid's original environment. Since this one is actually growing at right angles I just added some twigs as a support, and I think it looks fantastic.

Orchids always arrive trussed up and attached to plastic sticks. We unravel them and start again, the first step being to add twigs and moss round the base. Sometimes I tie tiny shells to the plant to give it a slightly oriental, faraway feel. They are expensive, but make a really good present as they can last for such a long time.

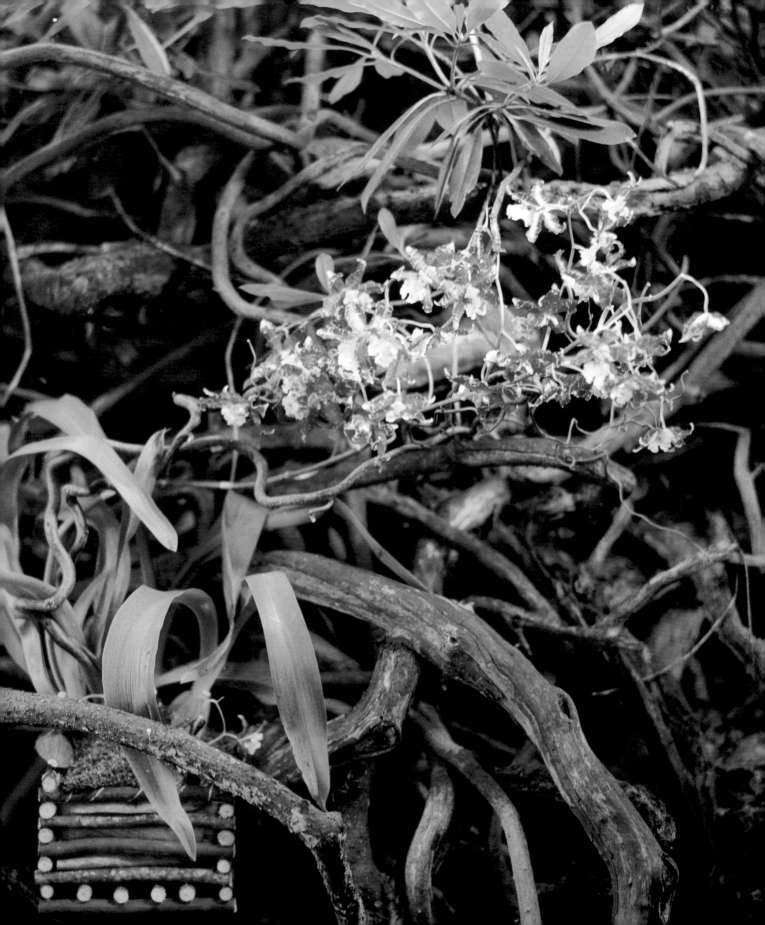

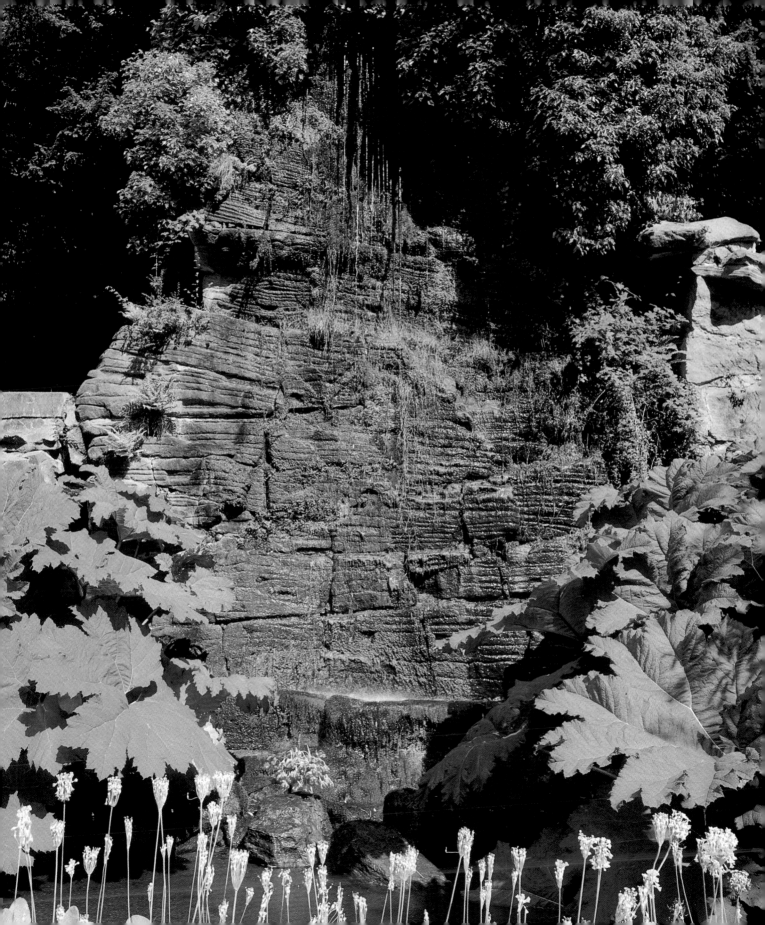

TULIPS

Tulips go on growing even after they are cut, giving them a slightly stubborn, untameable quality that I love. The shape and length of an arrangement can change overnight! Originally imported from the East, tulips were considered hugely exotic and rare by our forefathers – now they are commonplace, but they remain endlessly varied and beautiful.

I love the way they have a tendency to fall limply over the side of a vase. A big enough bunch can look like a waterfall of colour cascading down on to the table.

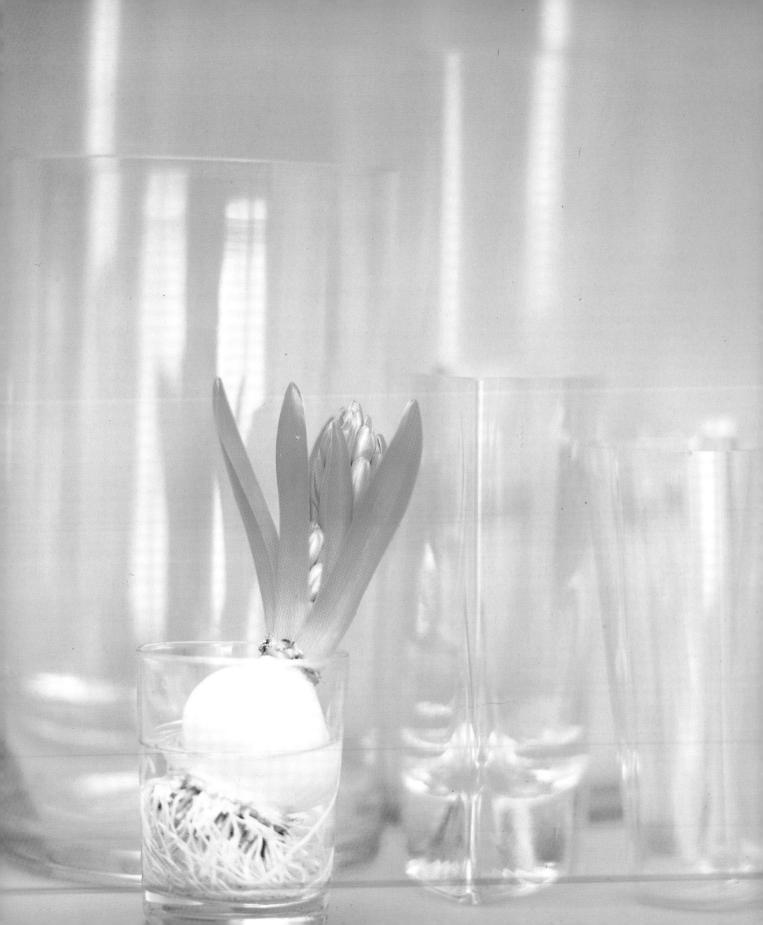

SEASONS

To some extent we are losing our sense of the season – flowers, like vegetables, that were once associated with particular months or seasons of the year are now readily available almost all of the time. This provides the florist with a curious dilemma. On the one hand, it's brilliant to have as many flowers as possible at any one time, but on the other hand, there's a kind of truthfulness about sticking to the seasons and knowing that the best sweet peas are English, and are only available in July and August.

Everyone has a favourite season – although I'd have to think hard to choose between spring and autumn, but I think that hyacinths, tulips and daffodils probably win out. Even though we no longer have the long, snowy, cold winters that I remember from my childhood, the first signs of new life – a sprinkling of snowdrops, or a cluster of crocuses, underneath a still leafless tree – are always welcome. Traditionally, gardeners used to throw the bulbs and plant them where they fell. Why not try it?

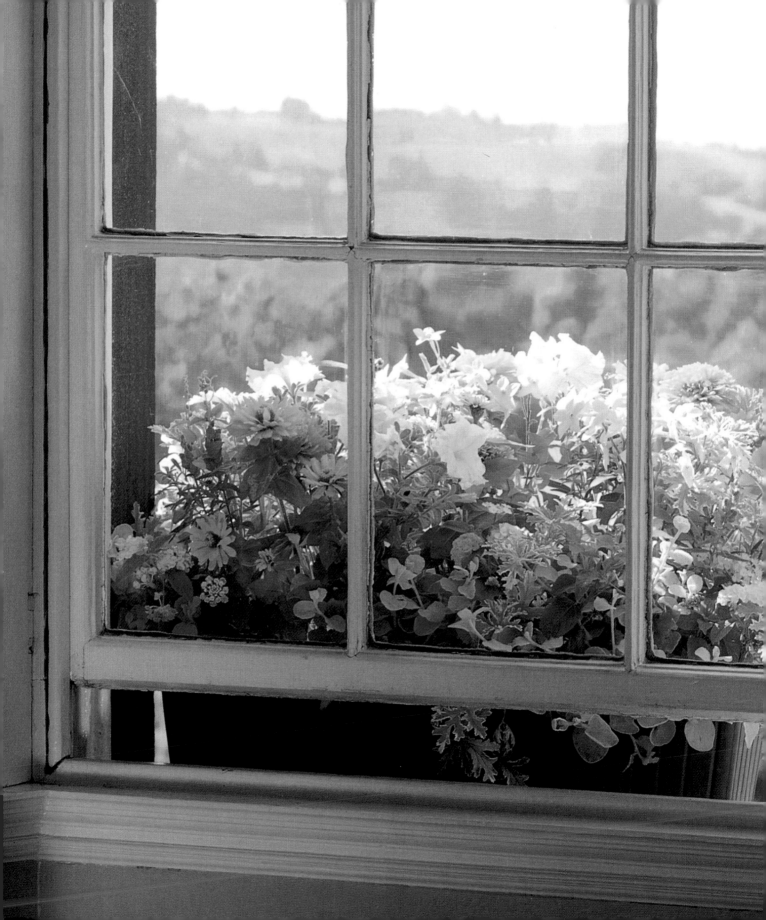

WINDOW BOXES

We used to make up the window boxes for the dining room and sitting room at Kensington Palace, and we would pick them up to replant them back in the shop about every three to four months.

During the summer we would use petunias, tobacco plants, antirrhinums, zinnias and lemon geraniums. Autumn or winter plants would be cyclamens, skimmias, heathers and primulas and polyanthus; early spring would be miniature daffodils, tulips, polyanthus and primulas.

The kitchen window boxes were always full of herbs that were used by the chef. These included sage, lemon balm, and nasturtiums, as well as the standards: rosemary, miniature tomato plants, pepper plants, mint, coriander and parsley.

We also tended to the plants on either side of the front door – big standard holly bushes in wooden planters were always there, but we would vary the underplants to reflect the flowers in the window boxes. Then as you walked into the hall there would be two jasmine plants or stephanotis – both chosen for their smell – about 6 to 7 feet high on either side of the door. The inner courtyard had large pots of magnolias and bay trees, but these were looked after by the Kensington Palace gardeners.

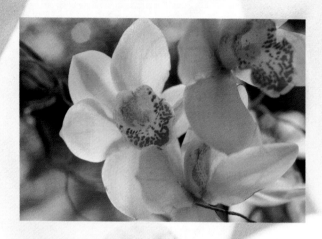

CYMBIDIUM ORCHID

This is a single *Cymbidium* orchid. When the *Cymbidium* was in season, in February to April and then again in July to August, the Princess would have huge plants, each with nine or ten stems and with a girth of about 3 to 4 feet, put into large blue and white pots. The colours are very delicate here, white with tinges of pink and green. This is a single plant, but the variety of foliage makes it look like something carefully assembled.

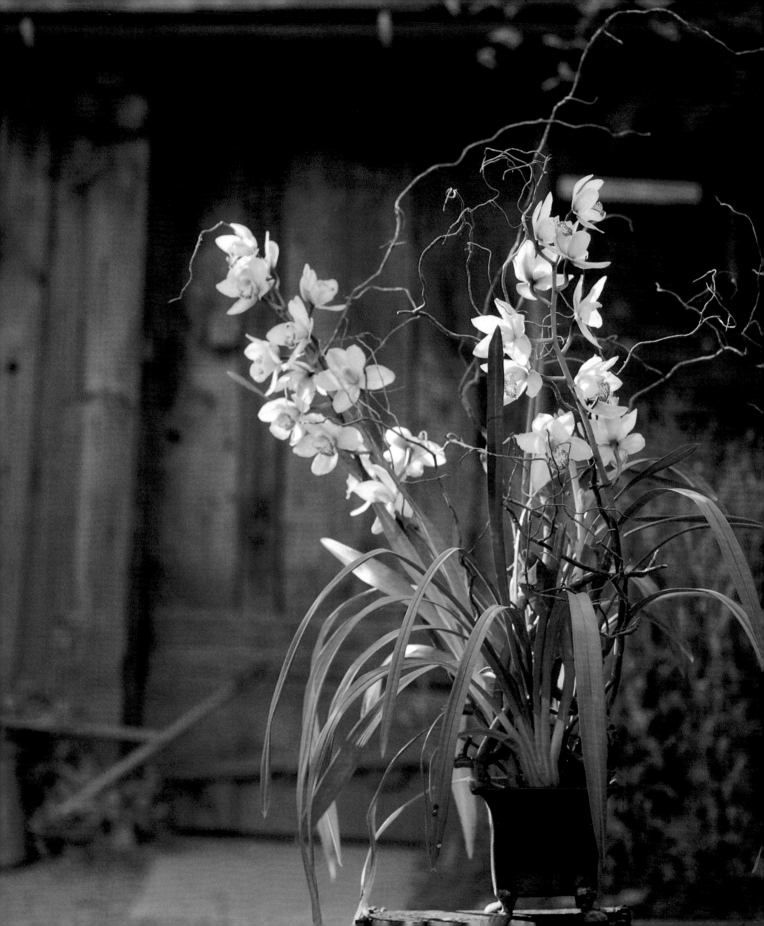

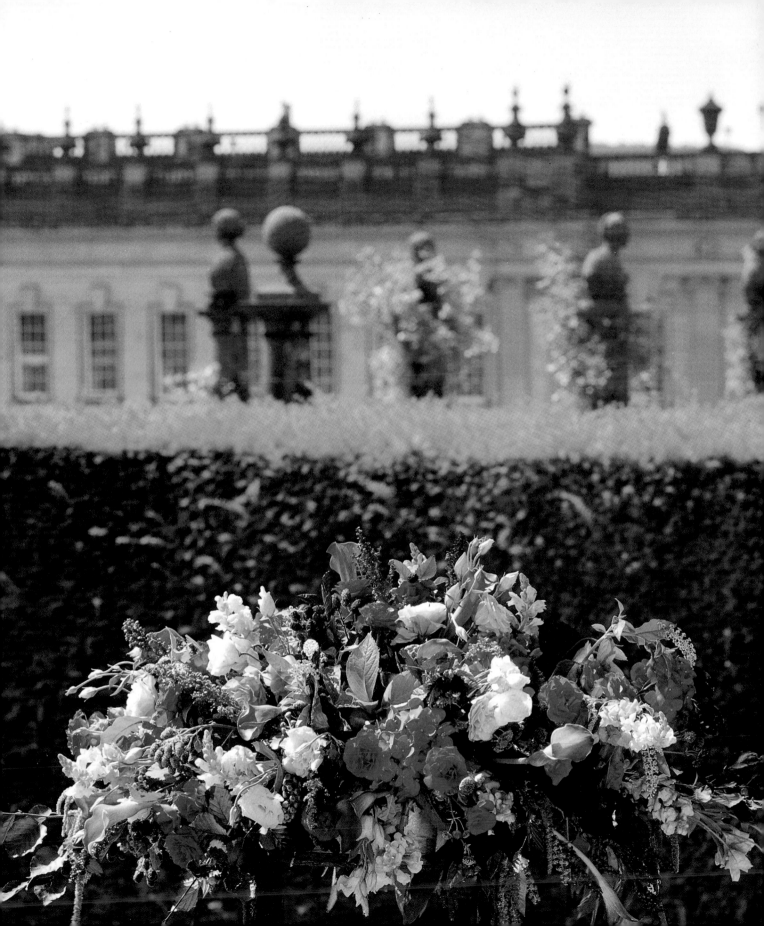

HYDRANGEAS

Hydrangeas are interesting. They tend to go in and out of fashion, but they can add structure to an arrangement, and the chalky intensity of their colours gives depth and weight. I usually use them in the autumn. But be careful – the early ones, in October, are very soft and don't last or dry. The closer to Christmas you can find them the better, when they'll last even if they're not in water.

The fine house in the background here is Chatsworth, the seat of the Dukes of Devonshire. The Prince and Princess of Wales visited Chatsworth many times together. The garden has almost everything. The first thing you see is a very formal garden, but this opens out into parkland and meadows with a backdrop of forests and moorland. Famously, the Devonshire family used to be able to travel from Devon to Derbyshire on their own land – perhaps they still can!

I grew up with Chatsworth as the backdrop to my childhood. One of my oldest schoolfriends works and lives on the estate. It's one of the most inspired and inspiring parks ever designed.

THE BEAUTY OF BULBS

I love planting out bulbs and putting them together with flowers in baskets, pots and trugs. There is a natural, elemental feel to all of these containers and I particularly like using old ones. I used a Victorian terracotta pot in the first arrangement for Diana.

The Princess particularly loved trugs filled with bulbs, so I'd plant out thirty hyacinth bulbs at a time in one. Hyacinths are sturdy and reliable, but also have such a great sweetness and prettiness about them when they flower. And, of course, the smell is fantastic. I like the bulbs to peek out over the surface of the earth so that you can see where they're coming from, their brown skins poking through.

When they have finished flowering, let them die back into the bulb, and then you can dry them out or simply plant them in the garden for next year. There is nothing as delightful as seeing the little green tips of spring flowers breaking through the soil.

Baskets of hyacinths were always a great favourite. Very simple and fresh, they provide a glimpse of spring and the promise of a future in the winter months.

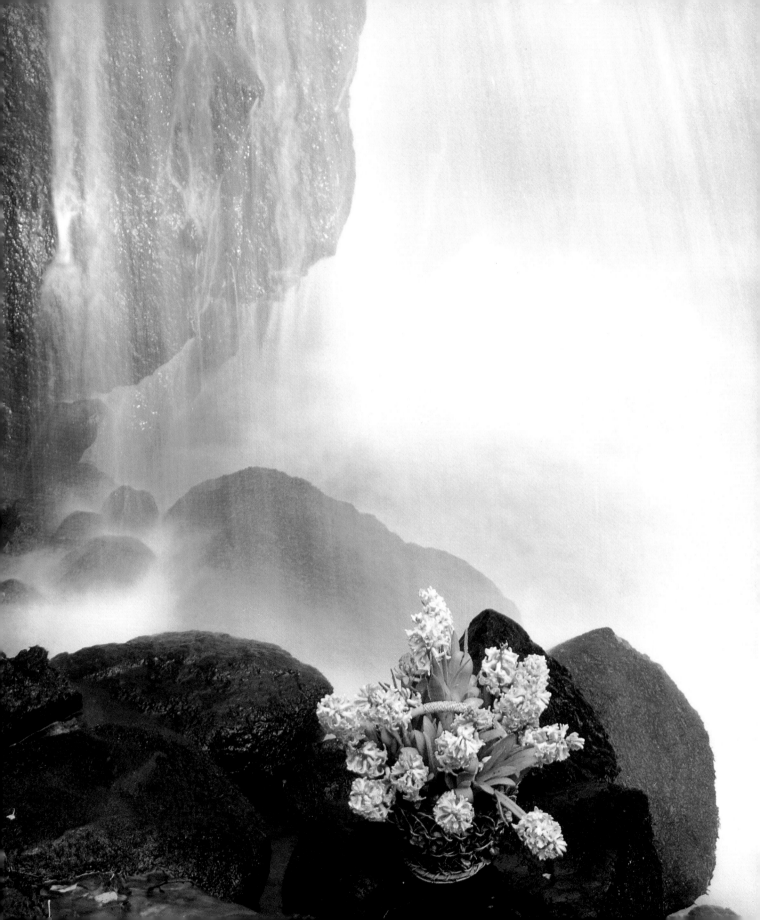

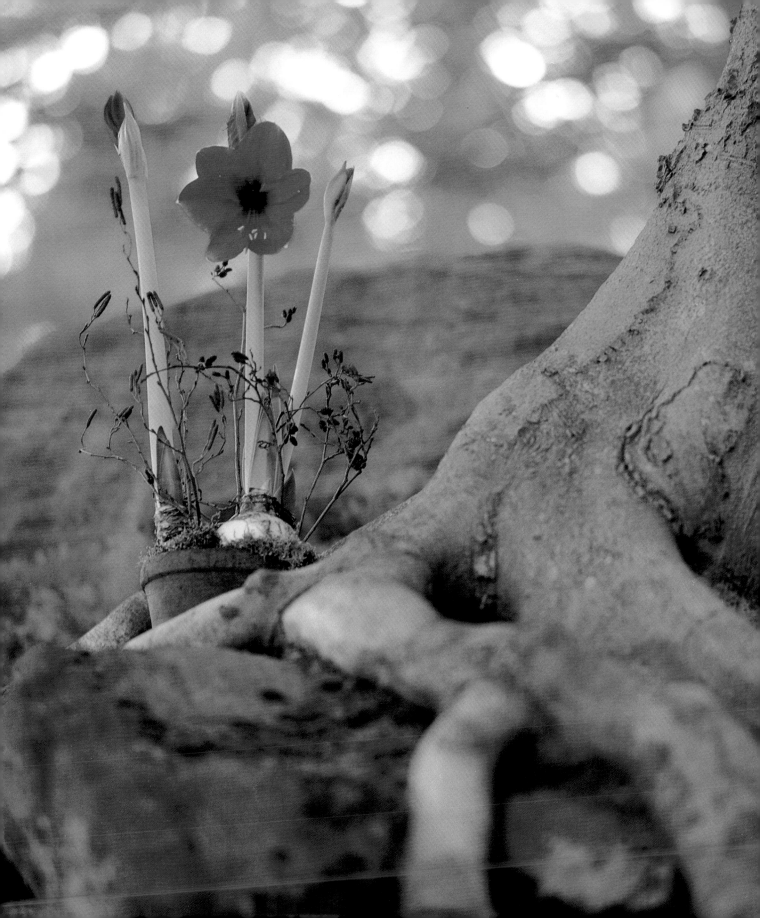

AMARYLLISES

The great thing about amaryllises is how fast they grow, and they also have a great combination of height and strength. I rarely mix them with other flowers; they lose their charm and just become another 'big' flower.

They make a wonderful Christmas present, because they are so immediately visual and beautiful but will continue to flower and cheer up any gloomy January day. Like the hyacinth, you can let them dry out and repot them around November for a repeat performance of their spectacular effect.

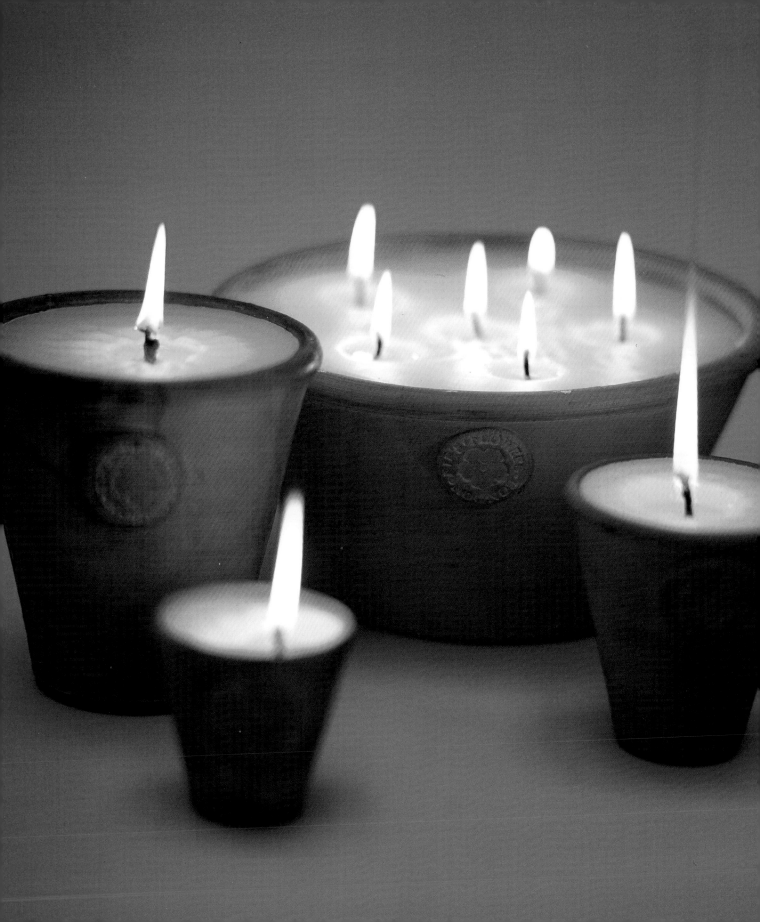

CHRISTMAS

Christmas was always a busy time. We'd get orders for flowers, candles, planted baskets and seasonal arrangements to be sent all over the place. For herself, Diana kept things relatively simple. She'd have a decorated swag round the front door, and always a tree – which we helped with on a couple of occasions, but really it was something she liked doing with Paul. For indoors, we'd use not only Christmas flowers, but nuts, cones, cinnamon sticks, apples and oranges, and we'd then sprinkle the whole thing with crushed cloves, cinnamon and star anise – strong smells, as always!

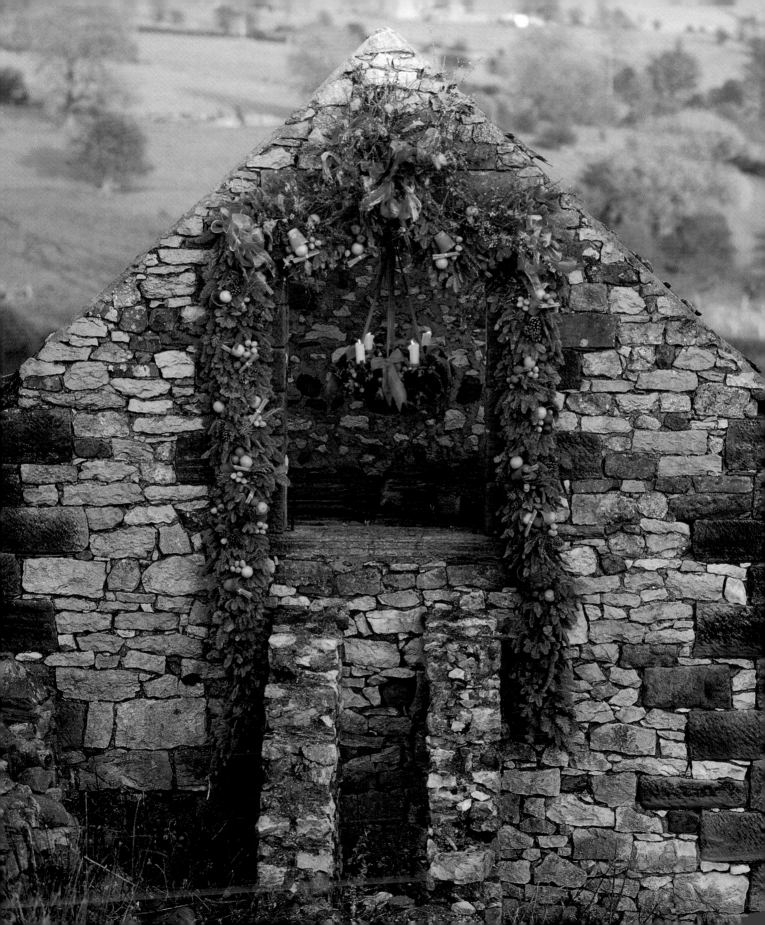

THE DOOR SWAG

We were asked to do a swag for the main
front door every year. The first time we used
a snake of chicken wire filled with moss,
bound with blue pine and wired all the way
round. We then decorated this with tiny
terracotta pots, apples, cinnamon and nuts –
which the squirrels from the park used to
come and eat. Some people would have
wanted the nuts replaced, but the Princess
loved to see them at it!

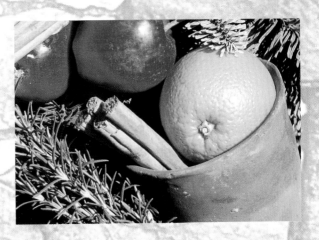

THE ADVENT WREATH

This decoration, for the weeks leading up to
Christmas, exemplifies many of the design
elements Diana loved and looked for in my
work. It has bold colours, delicious smells
and strong shapes. And the idea was for each
element to stand out in its own right as well
as to work together. Using dried nuts, cones
and bunches of cinnamon it's recognisably
Christmassy, but at the same time individual
and unusual. Using a kind of Protea called
Repens red provides more colour, and makes
it that bit more different from what you might
expect. Since it was designed to be hung up,
I had to pay as much attention to the
underneath as to the top part!

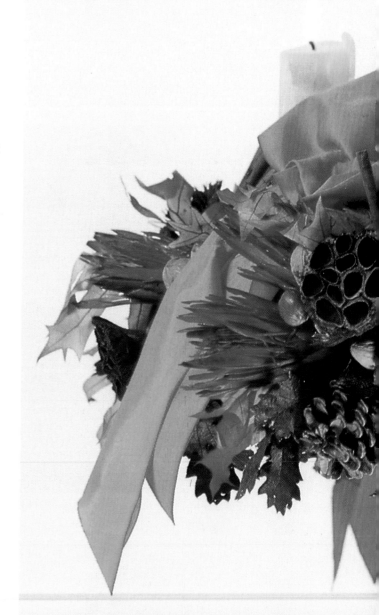

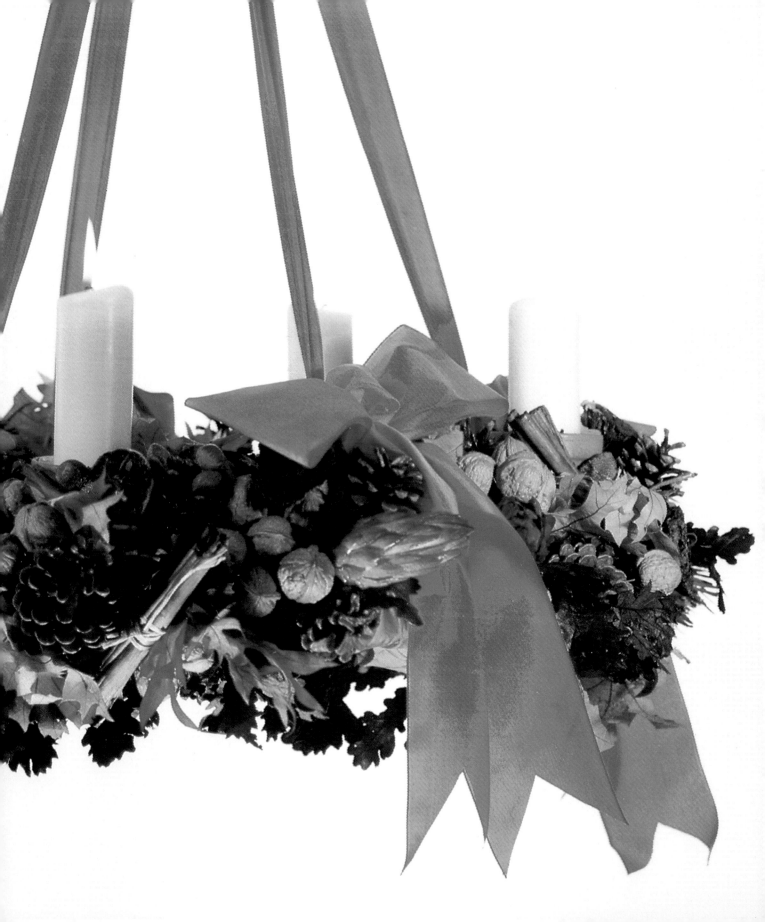

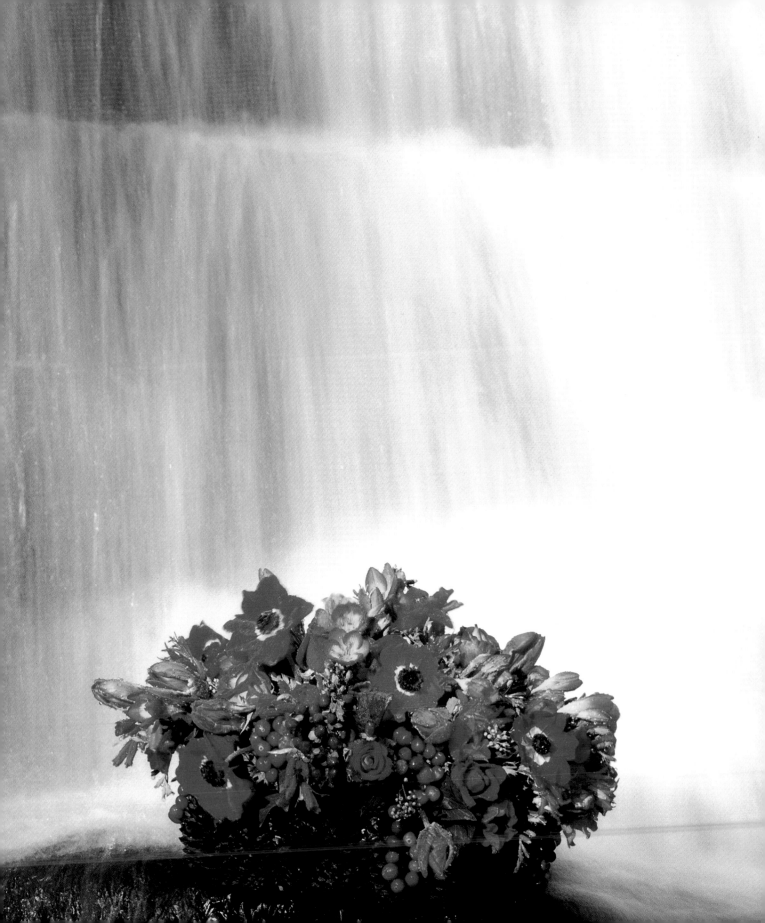

RED

This is red: very! It incorporates many of the same flowers, although red, of the next arrangement, which shows you what an impact colour can make. As well as the flowers, there are also loads of cranberries in there, which I threaded with cotton to tie into bunches. The basket, made with cones, is also filled with tulips, anemones, freesias and hypericum. It's Christmassy without using those old familiar standbys, holly and pine.

The only strong smell here is of the freesias, which have the appearance of extreme fragility but are very scented. I think the promise of spring in deep winter is very important.

The Princess brought life to the State Rooms of Kensington Palace with this sort of colour and scent. It was all part of the sense of variety and vitality she wanted in her home, which was also reflected in the mixture of components in any one arrangement. The boldness of the red also offers an element of strength and purity.

We photographed this arrangement at a natural waterfall where I used to play as a child in Matlock.

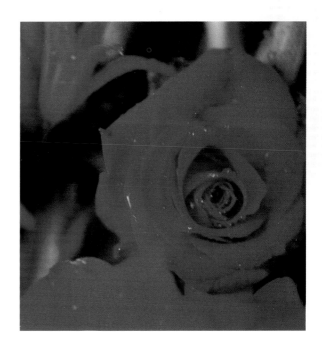

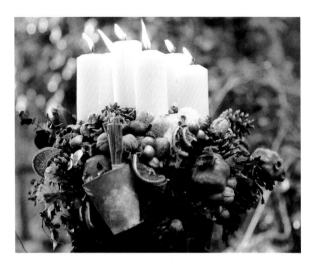

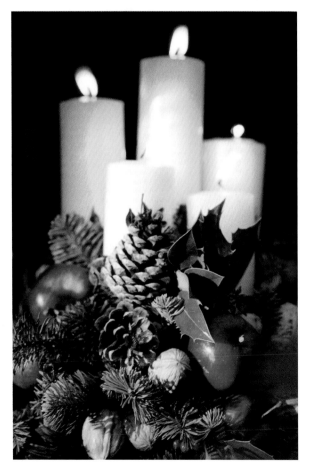

CANDLES

I would often provide cinnamon and clove candles for the apartments and for presents, whatever the time of year. Sometimes these were decorated. Whenever I went to Kensington Palace, Diana would have one burning in the hallway.

She loved five-candle arrangements in one bowl. It all started when I sent her round one as a present. We also did all sorts of things with preserved roses and berried ivy, or fresh fruit, nuts, holly and pine. Another approach was to wire dried pomegranates, dried orange slices, preserved oak leaves, bunches of cinnamon sticks, nuts, eucalyptus, pine cones and terracotta pots around the candles. All of these were sprinkled with spices.

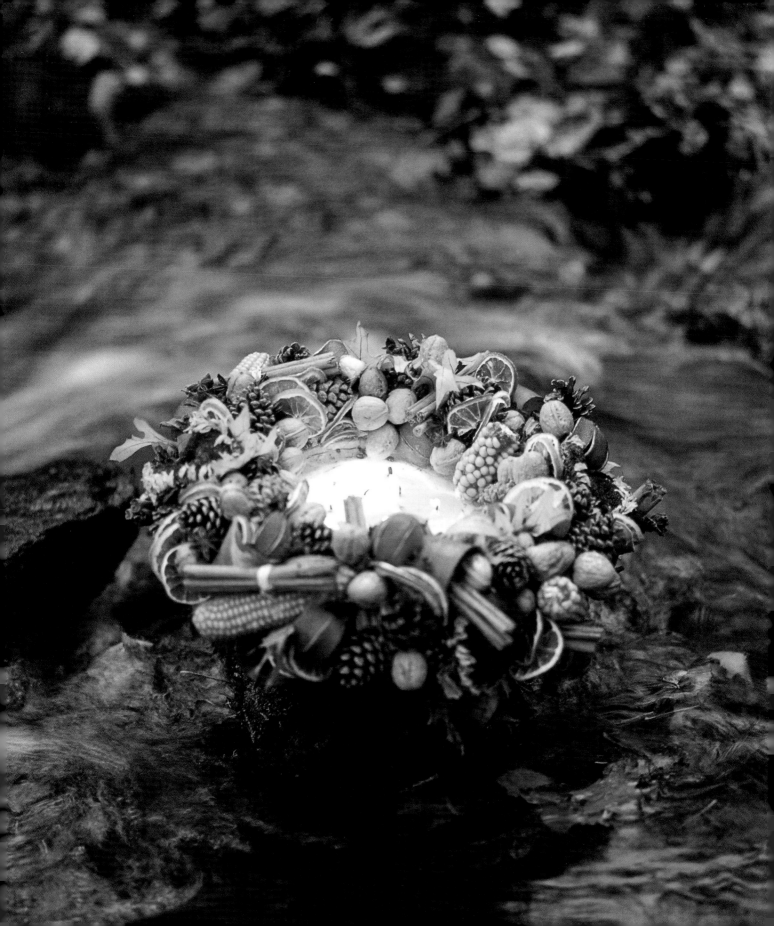

SILVER AND WHITE

This has a smart, clean, almost austere look, with none of the usual fussiness of Christmas. I wanted to get away from those predictable reds and greens and the smells usually associated with this time of year – but there's still a strong scent, of course! The almost unmistakable lilacs are quite heady, quite intense, and combined with what we call in the trade 'gum nuts' – essentially eucalyptus buds, silvery to look at, quite peppery and almost medicinal: they really cut through the fug of an urban winter.

The emphasis here is on different textures as opposed to colour, but the display remains both fresh and opulent – everything starts small, but as it flowers it fills out with miniature roses, tulips, lilac and my old favourites, *Lisianthius* and ranunculus flowers. I use them again and again in arrangements; by themselves they don't do anything for anybody, but combined with other flowers they really come into their own.

The basket is made of wire and wood – purists probably wouldn't mix the two, but with the right flowers it can look fantastic. This would probably have sat on a side table, but I also did scaled-down versions. The Princess loved the smell, of course, and its rather unorthodox yet still essentially Christmas feel. I think it's an arrangement with a sense of purity, which I hope and believe reflects what Christmas should be about.

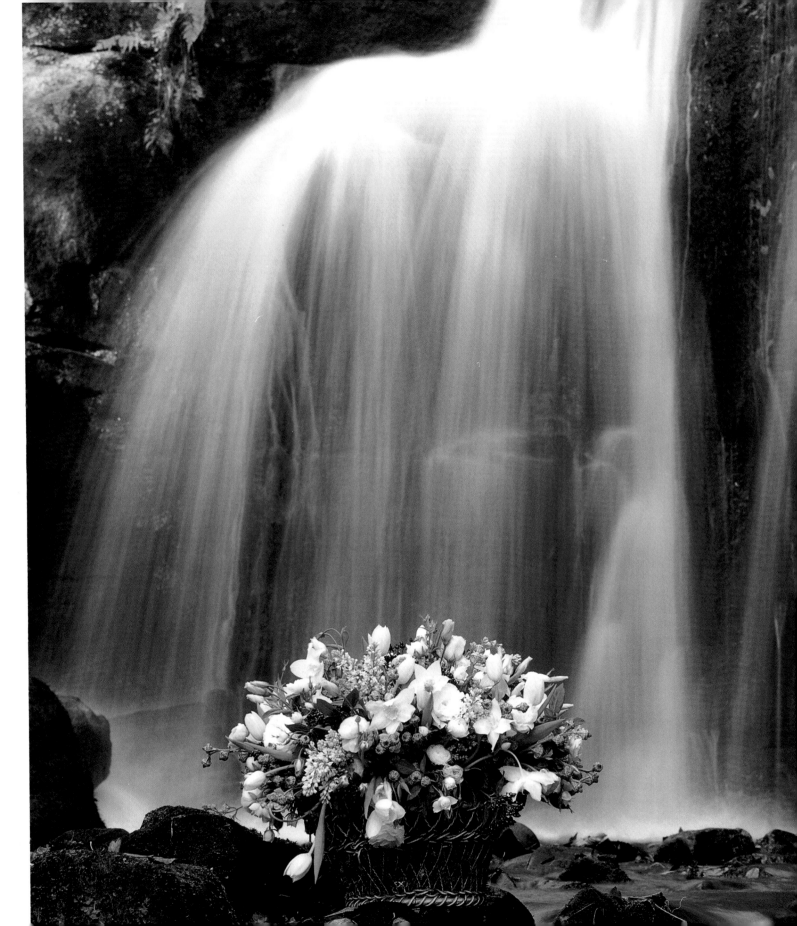

ACKNOWLEDGEMENTS

Especial thanks to Terry Barry, Paul Burrell, Brian Clarke, Clare Conville, Andy Earl, Sharon Hart, Mark Irving, Marian McCarthy, Jason Morais, Robert Phipps, Abi Russell, Steve Schwartz, Stephen Seedhouse, Isabel Urioste, Harriet Vyner, and Isobel Wolff for all their help and support in this project.

Also to those who helped in the locations for this project: John Oliver and Sean Doxey at Chatsworth House, Christopher Lloyd and Fergus at Great Dixter, Christine Constable at The Holt, Sheila Allen at the Orangery, and Robert Young and his family at Robert Young's Florist; Carol, Emily, William and Rowena.

The Sidgwick & Jackson team at Macmillan: David Macmillan, Gordon Wise, Fiona Carpenter, Neil Lang, Morven Knowles, Amanda Harris, Chantal Noel, Elizabeth Bond, Claire Anderson, Tess Tattersall, Nick Blake, Charlie Mounter, Ian Mitchell and Lee Bekker.

All my suppliers at New Covent Garden Market: W. H. Moss, Evergreen, N. R. Cole, Alagar, Baker & Duguid, R. Porter, C. Best, J. Austin, Gesst, Quality Plants, H. Miles, L. Mills, Arrnot & Mason, Something Special . . .

. . . and finally a big thank you to all my clients, customers and friends who make Kip's Flowers possible.

KIP